POSTCARD HISTORY SERIES

Inland Empire

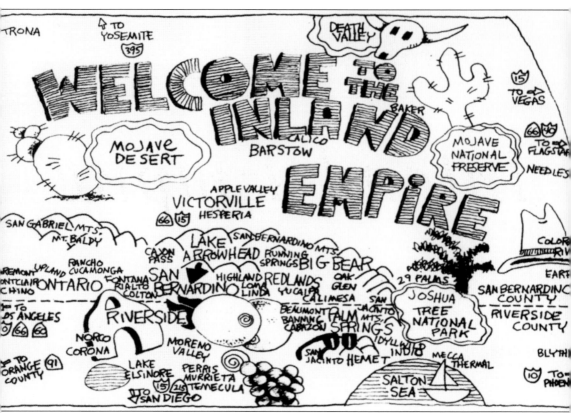

The Inland Empire is the great heartland of Southern California that lies east of the coastal metropolises of Los Angeles and Orange Counties. It consists of San Bernardino County, the nation's largest county, and Riverside County. It contains 150 communities and some of America's most famous mountain and desert resorts. (Courtesy of John Howard Weeks.)

ON THE FRONT COVER: Motor car excursionists stop to enjoy the view and take pictures on the new Rim of the World Highway, which opened in 1915, allowing auto travel from San Bernardino to fledgling resort communities in the San Bernardino Mountains. (Courtesy of John Howard Weeks.)

ON THE BACK COVER: An 1883 postcard takes artistic license in promoting "MAMMOTH NAVEL ORANGES" grown in Inland Empire orchards. Large-scale citrus production and new railroad links to Eastern markets combined to create what was called "California's Second Gold Rush." (Courtesy of John Howard Weeks.)

POSTCARD HISTORY SERIES

Inland Empire

John Howard Weeks

ARCADIA
PUBLISHING

Copyright © 2008 by John Howard Weeks
ISBN 978-0-7385-5907-0

Published by Arcadia Publishing
Charleston SC, Chicago IL, Portsmouth NH, San Francisco CA

Printed in the United States of America

Library of Congress Catalog Card Number: 2008924123

For all general information contact Arcadia Publishing at:
Telephone 843-853-2070
Fax 843-853-0044
E-mail sales@arcadiapublishing.com
For customer service and orders:
Toll-Free 1-888-313-2665

Visit us on the Internet at www.arcadiapublishing.com

CONTENTS

Acknowledgments 6

Introduction 7

1. The Valleys 9

2. The Mountains 65

3. The Deserts 93

ACKNOWLEDGMENTS

All the images in this book are from my personal collection of vintage postcards. Thanks to Brenda Markley, a good scout, who has helped me build the collection. She also helped me select the images for this book. Thanks to Jerry Rice for his assistance in proofreading the text. Thanks also to the many antique shop owners and dealers of the Inland Empire, who have seen a lot of me in recent decades. Thanks to the great host of people, living and dead, who have sent postcard greetings from the Inland Empire for more than a century and a half. Even greater thanks to those who thought to save those cards and preserve them, recognizing that a good postcard not only is a little work of art, but also a worthy historical artifact. And finally thanks to my enthusiastic editor, Debbie Seracini, and all the good folks at Arcadia Publishing, who with the Postcard History Series have created the world's best showcase for these treasures.

INTRODUCTION

The Inland Empire keeps being discovered. In the beginning, Native Americans discovered a lush, enclosed valley inland from the sea. Those men and women were awestruck by what they saw. The giant figure of an arrowhead, carved by some mighty force into a rampart of the surrounding mountains, seemed like a divine sign to them that they should settle here.

Later, in 1810, the region was discovered again. An explorer priest in search of hallowed ground for the establishment of a mission outpost was just as impressed as those first settlers. He named the valley San Bernardino in honor of a venerated saint whose feast day fell on that day.

In the 1850s, the region was discovered again. While gold seekers were rushing to other parts of California, Mormon settlers felt called by God to choose the San Bernardino Valley. They regarded the arrowhead as a providential sign, just as the indigenous people before them had done.

The city of San Bernardino was built, and it flourished. Other settlers came and built other cities, and they flourished, too. Great vineyards were planted, and so were millions of orange, lemon, and grapefruit trees. The heady wines from California's first wine country and the voluptuous citrus fruits from Inland Empire orchards caused a sensation throughout the nation.

As news spread of the Inland Empire's fertile soil, dry climate, sunny skies, and therapeutic hot-water springs, multitudes flocked here to see, and many decided to stay. Rich timberlands were discovered in the San Bernardino Mountains, and then gold, which sent waves of settlers heading for the hills. Mountain rivers were dammed to create lakes and eventually resorts. The discovery of silver and other precious minerals in the vast Mojave Desert spurred a migration there, too.

As the valleys, mountains, and deserts teemed with new activity, the railroads competed to lay track to accommodate the new traffic. Rail stations evolved into new cities. Old wagon trails evolved into auto roads, and in time, mighty industries were established in the Inland Empire, employing thousands of people. The federal government built military bases that employed many thousands more.

Then, as the region grew, so did problems. Inland Empire valleys became a catch-basin for Southern California's growing air pollution. Vineyards, citrus groves, and once-stately neighborhoods were lost to urban sprawl. The decline of the railroads wounded the economy. The shutting down or downsizing of numerous military bases and key industries hurt it more.

But now the Inland Empire is on the rise again. In fact, it is one of the fastest growing regions in the nation. It offers too many amenities to be overlooked in a crowded Southern

California. It has abundant artesian water. It has land. It has room to grow. It even has blue skies again, thanks to years of aggressive air quality controls.

The Inland Empire is loaded with other attractions, too. There are four mountain ranges dotted with famous resorts such as Lake Arrowhead, Big Bear Lake, and others. These resorts attract millions of visitors each year. The San Bernardino National Forest is the nation's busiest. The Santa Rosa and San Jacinto Mountains National Monument is one of the nation's newest national monuments. The area also has some of the world's most famous desert resorts and recreational areas, including Palm Springs, Death Valley National Park, Joshua Tree National Park, and the Mojave National Preserve. It is crazy, almost, to have mountain resorts right next door to desert resorts. Residents can ski at Bear Valley in the morning, then sunbathe in Palm Desert in the afternoon. Then they can watch the sun go down over the world's oddest body of water, the accidental Salton Sea. And wait, there's more.

Most of Southern California's Native American gaming casinos are in the Inland Empire, and they attract immense crowds both day and night. Sports fans by the hundreds of thousands flock to the Inland Empire for NASCAR events at the Auto Club Speedway in Fontana (the West's largest race track), for the annual Redlands Bicycle Classic in Redlands, for the Western Regional Little League Championships in San Bernardino, and for minor league baseball. In fact, almost all of Southern California's minor league ball teams are in the Inland Empire. Music fans trek to the Glen Helen Pavilion in Devore near San Bernardino, the Western Hemisphere's largest outdoor amphitheater, for mammoth rock and country events. Indio, in Riverside County, hosts the colossal Coachella Valley Music and Arts Festival each year.

The Inland Empire is heaven for car buffs, too. There are Route 66 museums in San Bernardino, Rancho Cucamonga, Victorville, Barstow, and Daggett. There are car shows and cruise nights almost every weekend of the year in communities throughout the region. The Stater Bros. Route 66 Rendezvous in San Bernardino draws more than half a million spectators each September.

The Inland Empire also has the West's largest shopping mall, Ontario Mills, which attracts more visitors each year than Disneyland. Visitors are drawn to such famous tourist attractions as the Mission Inn in Riverside, the Asistencia in Loma Linda, and the Redlands Bowl. The region also hosts California's official state outdoor play, the annual Ramona Pageant in Hemet.

The Inland Empire is still famous for its produce, too. The region hosts many of the nation's best-known food and harvest celebrations, including the National Orange Show in San Bernardino, the National Date Festival in Indio, the Grape Harvest Festival in Rancho Cucamonga, the Lemon Festival in Upland, Beaumont's Cherry Festival, and Oak Glen's Apple Harvest Festival. The Inland Empire is home not only to the state's oldest wine country, in the Cucamonga Valley of San Bernardino County, but also the state's newest wine country, in the Temecula Valley of Riverside County. Dozens of wineries draw tourists and wine lovers from around the world.

The Inland Empire is booming. It is big and getting bigger. There is plenty to see and plenty to do. And the weather is great year-round. It is no wonder that the Inland Empire, which has been discovered so many times in the past, is being discovered all over again.

One

THE VALLEYS

The Inland Empire has many valleys—the San Bernardino Valley, the West Valley, the East Valley, and others. These valleys contain most of the Inland Empire's cities and towns, large and small, and most of its people. In this chapter, the postcard history tour will take readers first to San Bernardino and other communities in its vicinity, including Highland, Colton, Rialto, and Fontana. Next the book will visit Riverside and a constellation of smaller Riverside County communities, including Norco, Corona, Lake Elsinore, Perris, Murrieta, Temecula, San Jacinto, and Hemet. The next stop will be Ontario and other West End communities, including Rancho Cucamonga, Upland, Claremont, and Chino. The final stop in this chapter will be Redlands and other East Valley communities, including Loma Linda, Yucaipa, Beaumont, and Banning.

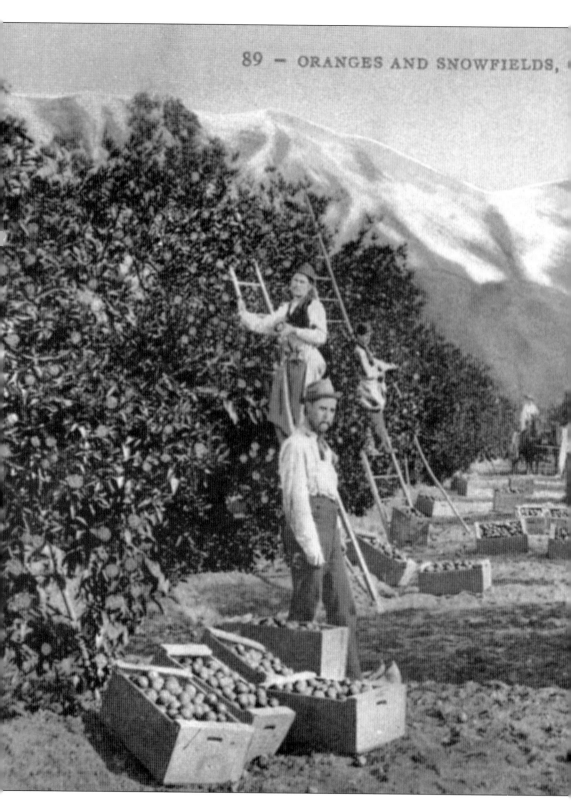

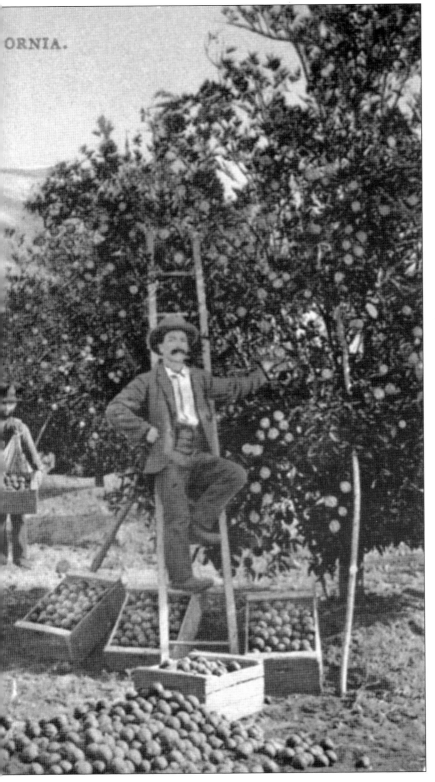

There once were an estimated 10 million orange trees in Southern California, most of them in the Inland Empire. A 1915 visitor sent this report home: "The oranges have been mostly gathered—and a view like this is common. That is—the crop of navel oranges has been gathered— but there are still orchards of Valencias that ripen later. But the orange blossoms for the next crop of navels are out now and the air everywhere is heavy with fragrance. This p.m. I passed an auto at the side of the pavement. No one was in it but it was piled high with big oranges. There was hardly room for the chauffeur. Wouldn't that be a strange sight in New England?"

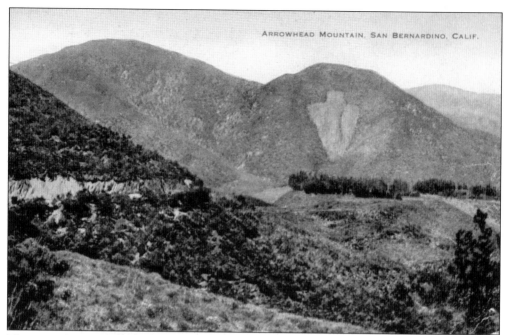

The natural arrowhead formation in the mountain foothills north of San Bernardino is caused by contrasting soil and rock composition. It has survived fires, earthquakes, erosion, vandalism, and the passage of centuries. It was venerated by indigenous people and white settlers alike.

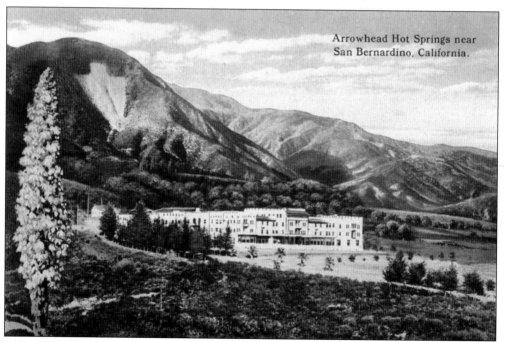

A foothill oasis known as Arrowhead Springs, directly below the arrowhead formation, has been the site of four spa resorts dating to the 1880s, each one more lavish than the last. The first three burned to the ground, including this one, the Arrowhead Hot Springs Hotel, which was built in 1905 and destroyed in 1938.

Coldwater Canyon, near San Bernardino, California.

The hot mineral springs, at 202 degrees Fahrenheit, are considered the world's hottest, but Arrowhead Springs has cold water, too. In fact, its cold-water springs, seen here, are the signature source of water for the Arrowhead Mountain Spring Water Company, which has filled its tankers here since 1903.

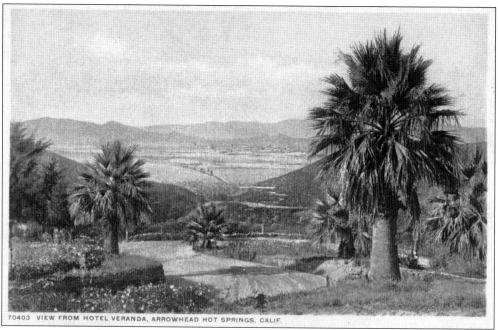

70403 VIEW FROM HOTEL VERANDA, ARROWHEAD HOT SPRINGS, CALIF.

The San Bernardino Valley is a wide-open expanse in this postcard of about 1910, which shows the view from the veranda of the Arrowhead Hot Springs Hotel. A dirt road rutted with wagon wheels and probably early auto tires can be seen leading up to the foothill spa, which attracted a well-to-do clientele.

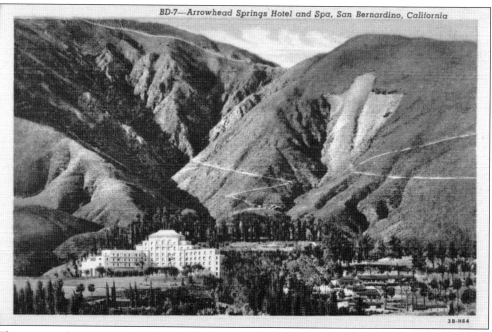

BD-7—Arrowhead Springs Hotel and Spa, San Bernardino, California

The present-day Arrowhead Springs Hotel was built in 1939 and was a popular getaway for the Hollywood crowd. Elizabeth Taylor honeymooned here in 1950 with hotel heir Nicky Hilton. Campus Crusade for Christ purchased the hotel in 1962 and based its operations here until 1991. Today the hotel awaits redevelopment.

14

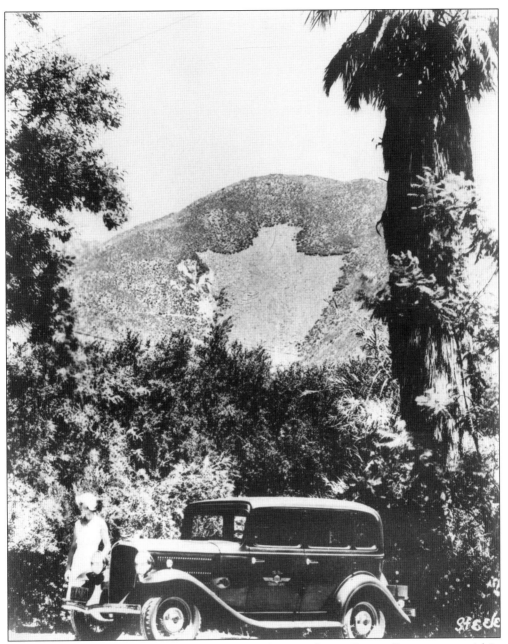

In this 1920s image, captured on a foothill road in north San Bernardino, a pretty girl in flapper attire poses next to a motorcar with the famed arrowhead landmark visible in the background. For more than 150 years, the arrowhead has been the Inland Empire's most recognizable landmark.

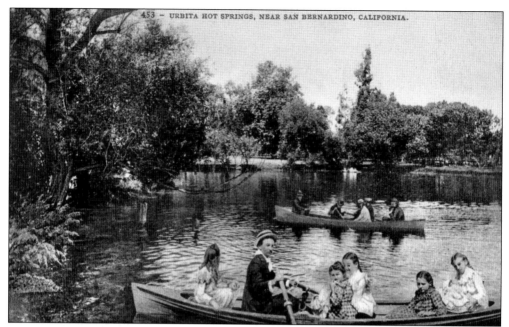

San Bernardino's abundant groundwater was fully utilized as a recreational resource during the early 1900s. Urbita Springs, in the southern portion of the city, attracted visitors from throughout Southern California. On this postcard, dated 1907, is scribbled, "This is beautiful don't you think."

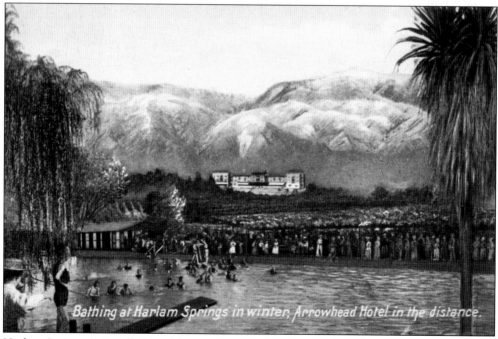

Bathing at Harlam Springs in winter, Arrowhead Hotel in the distance.

Harlem Springs (misspelled on this 1910s postcard) was a popular lake resort in the northeast portion of San Bernardino, near present-day Highland. Trolley cars provided transportation between Harlem and Urbita, so fun seekers could visit both in a day. The old Arrowhead Hot Springs Hotel is visible in the background.

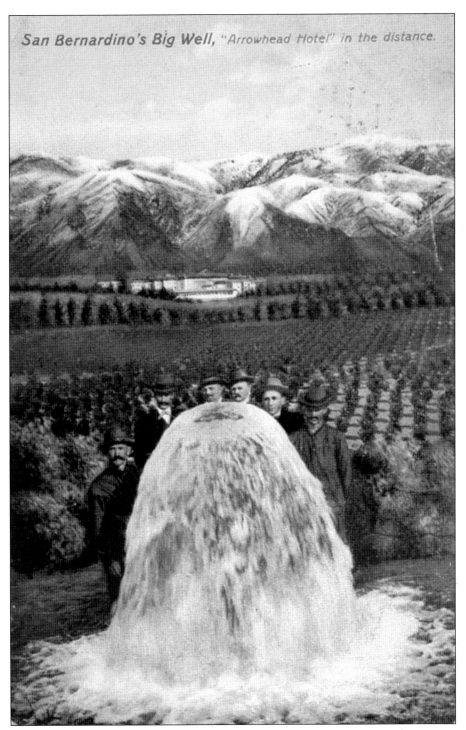

San Bernardino's Big Well, "Arrowhead Hotel" in the distance.

San Bernardino is located on the edge of the Mojave Desert, but it has plenty of water. Experts believe that it sits atop an artesian basin larger than Lake Tahoe. The well seen here, with these gentlemen standing around it, is shown on many early-20th-century postcards and promotional leaflets.

This rare postcard was issued as a promotion for the first National Orange Show, held in 1911 in a circus tent in downtown San Bernardino. The advertisement on the back, printed in orange ink, says, "Meet me at the National Orange Show, San Bernardino Cal., March 6th to 11th, 1911."

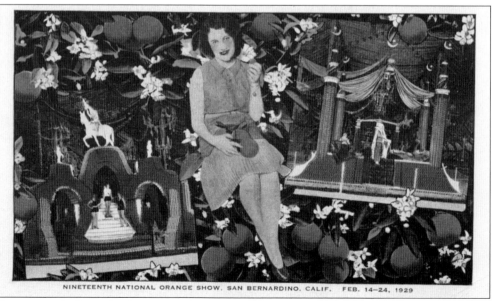

Permanent facilities for the National Orange Show were built beginning in the 1920s. Seen here is a postcard promoting the 19th edition, held in 1929. It says, "No trip to California is complete without a visit to the National Orange Show, the most beautiful exposition in all the world." The annual event continues to this day.

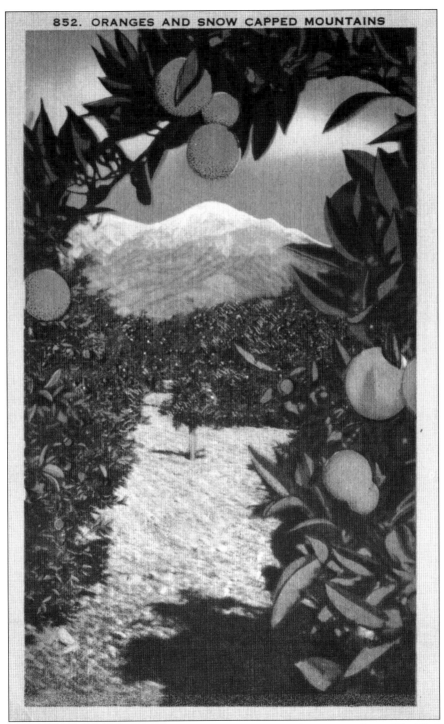

852. ORANGES AND SNOW CAPPED MOUNTAINS

Inland Empire citrus fruit varieties won 20 gold medals at the New Orleans World's Fair of 1884. National demand soared. In 1893, local growers established the California Fruit Growers Exchange, which evolved to become Sunkist Growers, Inc., still the world's largest fruit-marketing cooperative.

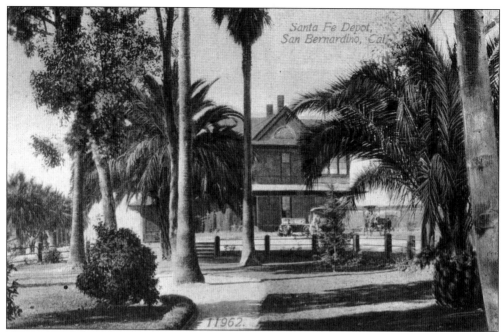

San Bernardino's future as a transportation center was assured in 1883 when the Santa Fe Railroad came to town. Trains arrived full of tourists and departed full of citrus fruit. The original wooden depot, seen here through an adjoining park, was built in 1886. It burned in 1916 and was replaced two years later.

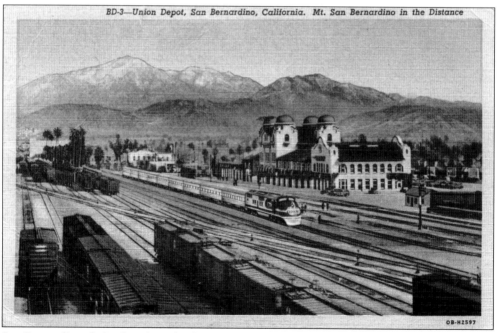

San Bernardino thrived as the Inland Empire's primary transportation hub. A Moorish-styled rail depot built in 1918 served both the Santa Fe and Union Pacific Railroads. The structure still stands. The view here is eastward, with the San Bernardino Mountains visible in the distance.

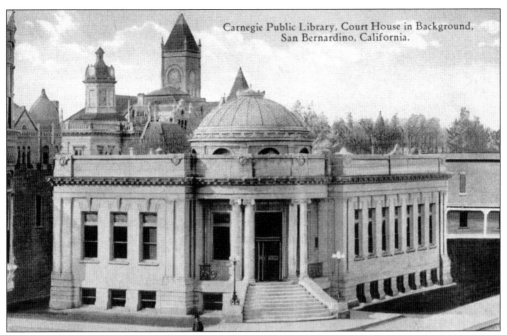

Carnegie Public Library, Court House in Background, San Bernardino, California.

San Bernardino's Carnegie Public Library, funded by industrialist Andrew Carnegie, was built in 1904. It was one of many stately buildings to rise in the downtown area during the early 20th century. Carnegie also funded libraries in Riverside, Colton, Corona, Hemet, Beaumont, Claremont, Upland, and Ontario.

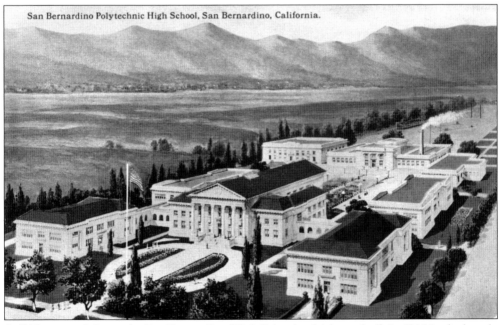

San Bernardino Polytechnic High School, San Bernardino, California.

A 1919 postcard shows the San Bernardino High School, which was built in 1915 in the largely undeveloped countryside of north San Bernardino. In fact, parents complained about its remote location. The sender of this card noted on the back, "This is the cleanest town you can imagine. Almost all the houses are white."

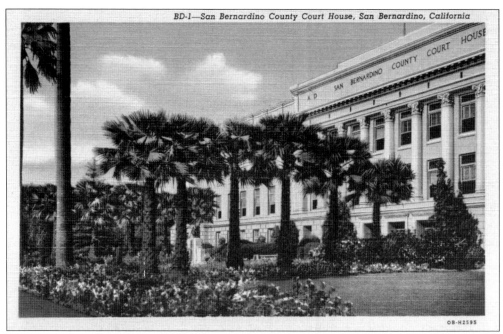

The present-day San Bernardino County Court House, seen here in a 1950s postcard view, was built in 1926 on the site of the city's original Mormon Stockade, a fortress built by the city's founders in 1851. The settlers feared Native American attacks that never materialized, and the fort soon was abandoned.

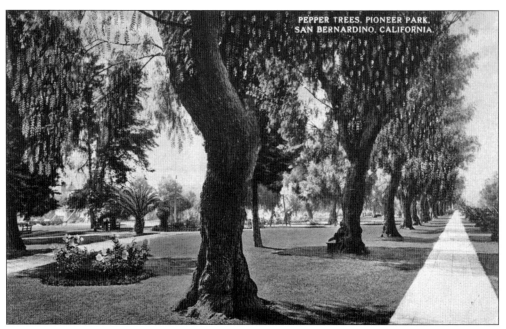

Pioneer Park in downtown San Bernardino is seen in a 1931 postcard sent by a visitor who wrote, "This is a great place. It's all they say it is and I would just as soon stay here to live." In those days, the park was home to the city's Municipal Auditorium. Today the city's main library occupies the site.

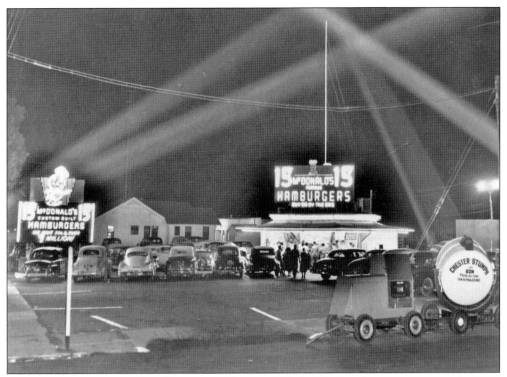

Richard and Maurice ("Mac") McDonald opened their first hamburger restaurant in 1940 at Fourteenth and E Streets in San Bernardino. In 1948, mindful of the new car culture, the brothers converted McDonald's to a drive-in, seen here on the night of its grand opening. It is the moment America's fast-food industry was born.

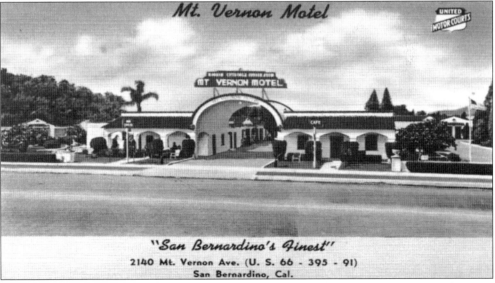

Before the completion of freeway projects in the 1950s and early 1960s, Route 66 was the main travel road through San Bernardino County. From Arizona, it passed through Barstow and the High Desert, then down the Cajon Pass into San Bernardino, where it followed Mount Vernon Avenue south, then Fifth Street west.

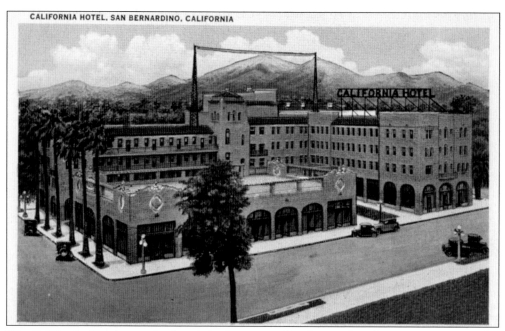

The California Hotel was a landmark in downtown San Bernardino from 1927 to 1985. The city's first radio station, KFXM, which is still in operation today, broadcast from a studio located in the lobby. Singer Tennessee Ernie Ford started his career as a disc jockey here in 1946–1947.

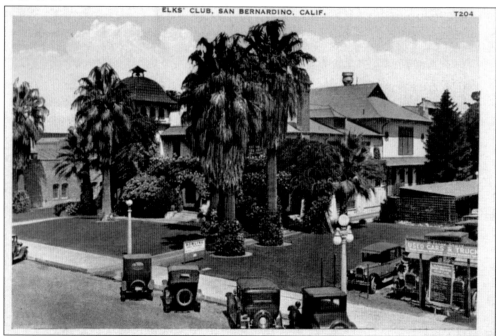

The San Bernardino Elks met in this baronial downtown lodge from 1908 until 1961. It was considered a jewel of the Elks organization in California and was called the "Host of the Coast." In 1961, the Elks relocated north to the top of Perris Hill overlooking Highland Avenue. The old building was demolished.

This old postcard is titled "Mt. San Bernardino by Moonlight." The image of mountain peaks framed by foliage has been favored by generations of Inland Empire photographers and painters. Images like this are seen on countless early-20th-century postcards, leaflets, and advertisements used to promote the region.

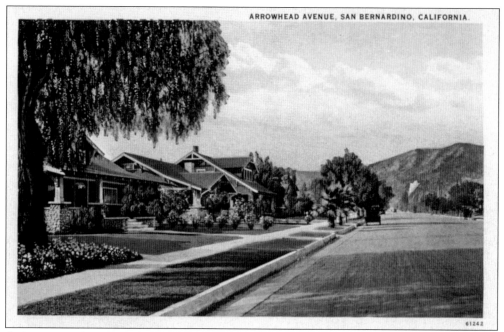

61242

As San Bernardino grew, wide boulevards and gracious neighborhoods expanded northward to the foothills. Many of the city's major north-south streets bear names that evoke the mountains, including Sierra Way and Mountain View. This Arrowhead Avenue postcard artfully shows the arrowhead landmark in the distance.

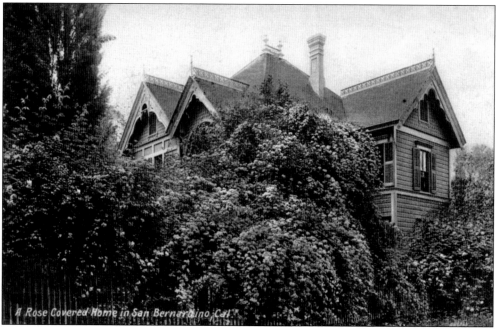

A Rose Covered Home in San Bernardino Cal.

This 1908 postcard, titled "A Rose Covered Home in San Bernardino, Cal.," was sent to Winnipeg, Canada, inscribed as follows: "Wish you were here to see this, which is just opposite where we live. It is too lovely & so many of the homes are like this. Glorious weather. You would go wild here."

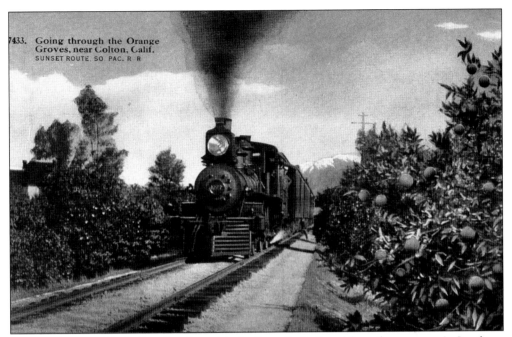

7433. Going through the Orange Groves, near Colton, Calif.
SUNSET ROUTE. SO. PAC. R R

The Southern Pacific Railroad, vying with the Santa Fe Railroad for rail supremacy in Southern California, built its Sunset Route eastward from Los Angeles starting in 1873, reaching Colton in 1875. Eventually, the line was extended to Texas, where it joined other rail lines to form the nation's second transcontinental route.

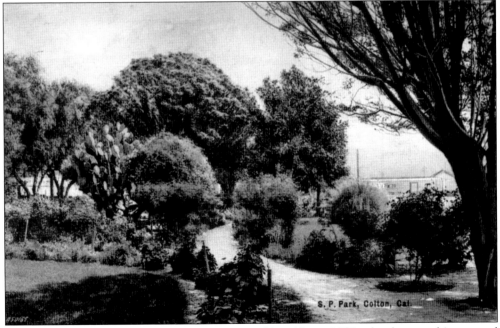

Perhaps it was a salesman of the time, writing to his wife or girlfriend, who sent this postcard in 1909 from the Southern Pacific Depot and Southern Pacific Park in Colton. The message reads, "Dear Kitty, Have finished up Corona & Riverside. I take next car to Berdoo at 10:00 & I will work 1 store or so & go to bed."

27

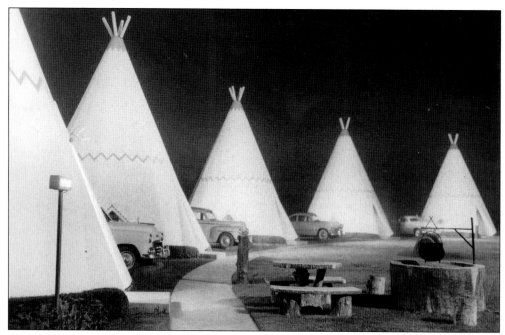

The California Wigwam Motel was built in 1949 on Route 66 between San Bernardino and Rialto. It became an iconic Route 66 landmark. The last in a chain of seven similar motels built across the south and southwest, it is one of only three that survive. The others are in Holbrook, Arizona, and Cave City, Kentucky.

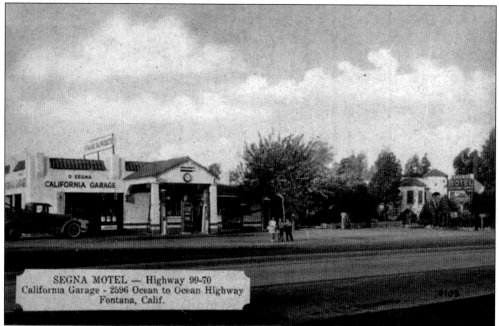

The California Garage in Fontana was a mainstay on old Highway 99-70, which in 1926 was designated Highway 66. The car culture always has been strong in Fontana. Today it is the site of the Auto Club Speedway, which opened in 1997 on the former Kaiser Steel site. It is the largest auto speedway in the western United States.

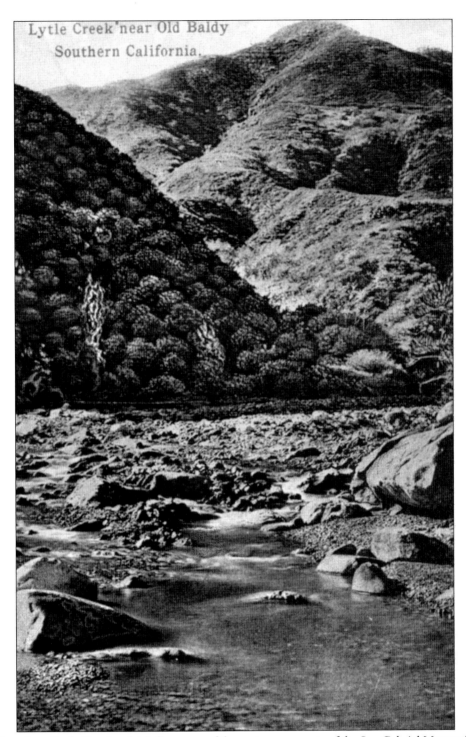

Lytle Creek near Old Baldy
Southern California.

Water from Lytle Creek, which flows out of the eastern ramparts of the San Gabriel Mountains, helped Fontana grow. Many of Fontana's streets are named after its crops, including Lemon Street, Tangelo Avenue, and Citron Court. A few miles north of Fontana, the rustic foothill community of Lytle Creek also still thrives.

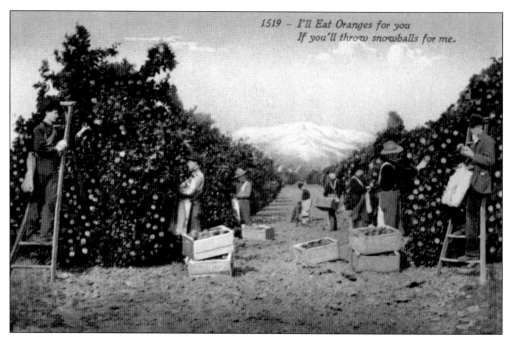

Snowbound Easterners were endlessly fascinated by reports of the mid-winter citrus harvest in Southern California. The concept was such a novelty it resulted in a popular quip seen on many postcards and advertisements of the day: "I'll eat oranges for you if you'll throw snowballs for me."

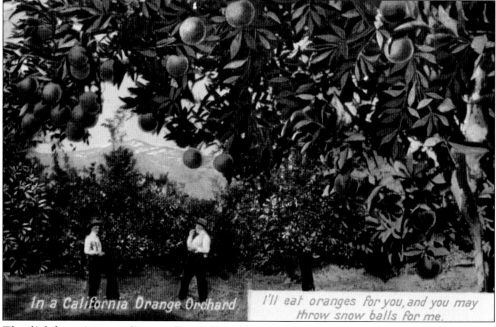

The slightly variant wording on this card is, "I'll eat oranges for you, and you may throw snow balls for me." Two gentlemen in their shirtsleeves are seen enjoying winter fruit. The card was mailed on December 30, 1908, to Maine by a correspondent who noted the transcontinental distance by writing, "Happy New Year from the Coast!"

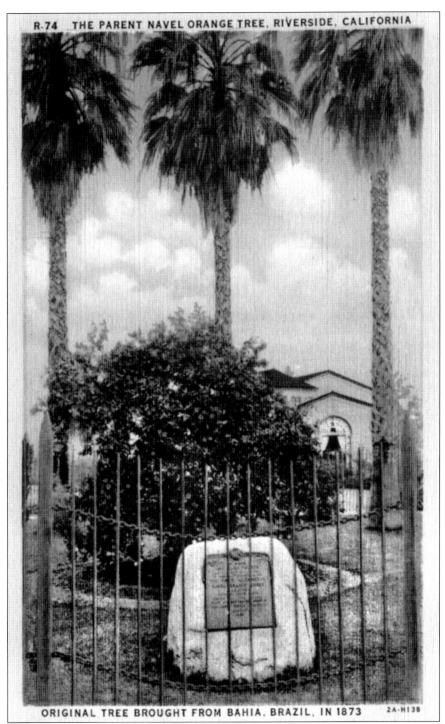

R-74 THE PARENT NAVEL ORANGE TREE, RIVERSIDE, CALIFORNIA

ORIGINAL TREE BROUGHT FROM BAHIA, BRAZIL, IN 1873 2A-H138

Now the tour turns south to Riverside, the queen city of Riverside County. The parent navel orange tree, which sired the entire Southern California navel orange industry, was imported to Riverside from Brazil in 1873. It can still be seen today in a special enclosure in a small park at the corner of Magnolia and Arlington Avenues.

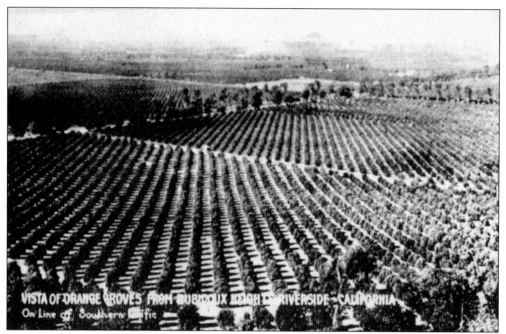

Citrus groves are as far as the eye can see! It was more than an expression during the early years of the 20th century in the Inland Empire. This postcard from about 1910, circulated by the Southern Pacific Railroad, features a photograph taken from the Rubidoux Heights neighborhood of Riverside.

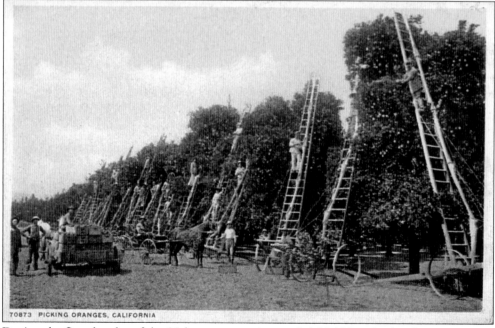

During the first decades of the 20th century, trains carried 30,000 carloads of oranges out of the Inland Empire each year. That was 12 million orange crates full of fruit, a cash crop worth $20 million. During the heyday of navel orange production, Riverside was the wealthiest city per capita in the United States.

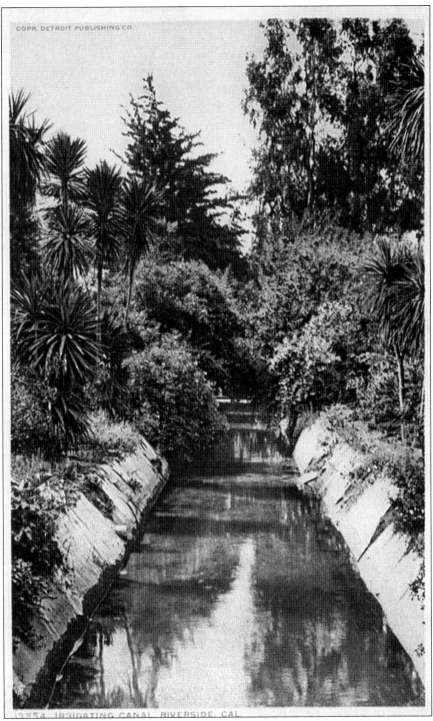

COPR. DETROIT PUBLISHING CO.

IRRIGATING CANAL, RIVERSIDE, CAL.

Riverside was once in San Bernardino County, but it resented San Bernardino's dominance of local politics. In 1893, it seceded and formed its own county. Ironically, though, Riverside was and is dependent on San Bernardino for its water. Riverside has little groundwater, while San Bernardino is water-rich.

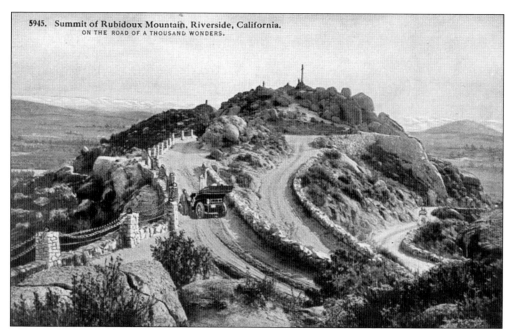

Riverside's Mount Rubidoux once was owned by Frank Miller, who built the Mission Inn. In 1907, he directed that a wooden cross be erected on top of the mountain, and in 1909, the first Easter sunrise service was held here. Fifty years later, in 1959, a concrete cross replaced the deteriorating wooden one.

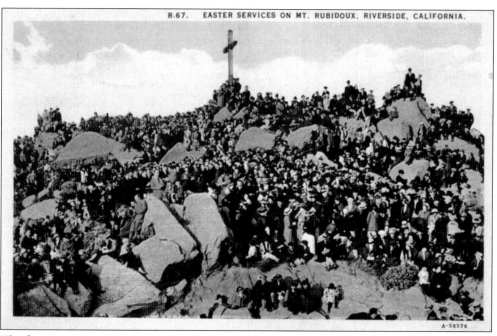

R.67. EASTER SERVICES ON MT. RUBIDOUX, RIVERSIDE, CALIFORNIA.

The first Easter sunrise service at Mount Rubidoux in 1909 drew 100 people. Within a decade, crowds of 20,000 were common. The tradition continues today. This 1931 postcard was scribbled with the following message: "This certainly is God's Country. Beautiful Air and Sunshine and Wonderful Scenery and drives."

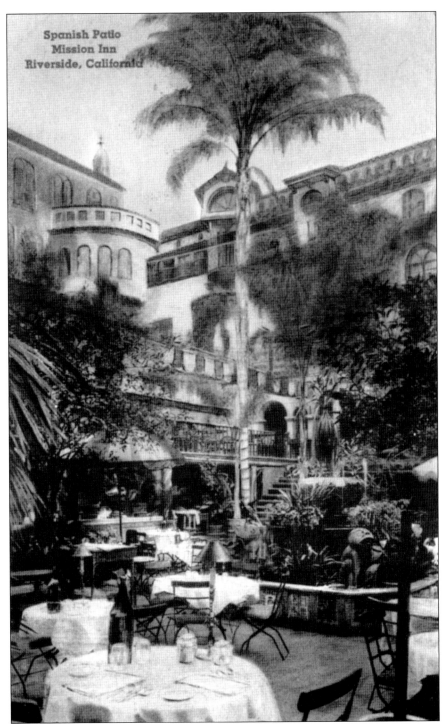

Spanish Patio
Mission Inn
Riverside, California

Riverside's famous Mission Inn never was a mission. It has always been an inn. In 1876, a guesthouse called Glenwood Cottages opened on the property. In 1882, the inn was enlarged and renamed the Glenwood Hotel. That establishment was replaced by the present structure, which opened in 1903 as the Glenwood Mission Inn.

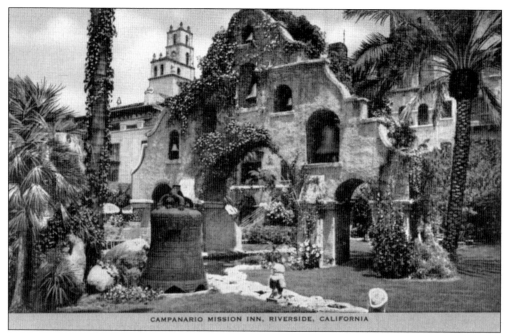

CAMPANARIO MISSION INN, RIVERSIDE, CALIFORNIA

The Campanario, a signature edifice located in the Mission Inn's main courtyard, is modeled on the bell arches of the San Gabriel Mission in the San Gabriel Valley of Los Angeles County. It was a priest from the San Gabriel Mission named Francisco Dumetz who discovered and named the San Bernardino Valley in 1810.

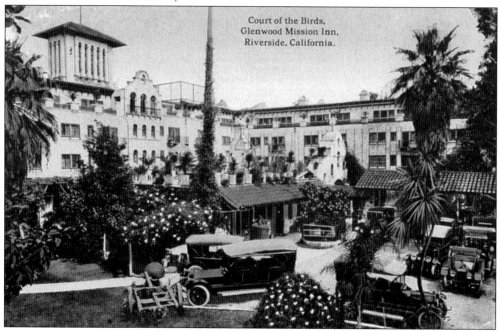

Court of the Birds,
Glenwood Mission Inn,
Riverside, California.

A primary investor in the Mission Inn was Henry E. Huntington, the railroad tycoon who also built the famous Huntington Library and Gardens in Los Angeles County. Huntington, who was on friendly business terms with Mission Inn founder Frank Miller, put up $75,000 of the hotel's $250,000 construction costs.

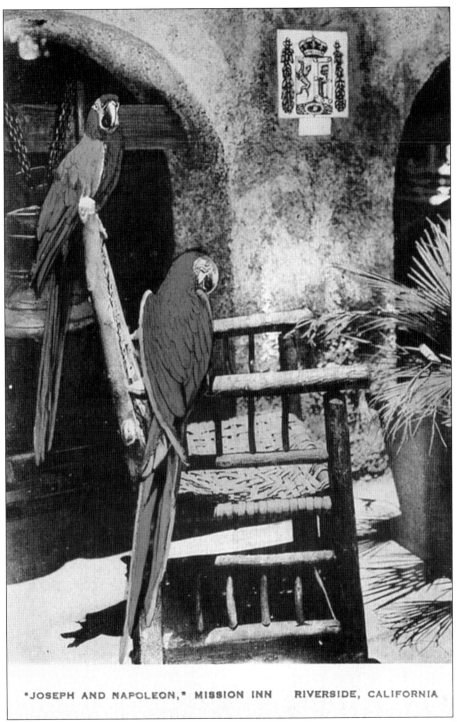

"JOSEPH AND NAPOLEON," MISSION INN RIVERSIDE, CALIFORNIA

Joseph and Napoleon were two Brazilian macaws who became the unofficial mascots of the Mission Inn. Joseph, top, had a multicolored coat of feathers, while Napoleon's plumage was royal blue. The inn's Court of the Birds is named after the pair. Countless tourists posed for pictures with the friendly creatures.

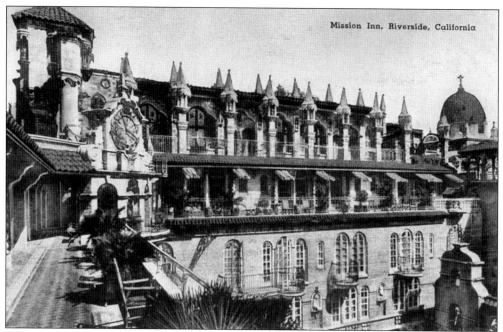

The Rooms of the Authors, overlooking the Spanish Patio, were added in 1938. The suites were named after prominent writers of the day who stayed at the inn. Among these were Harold Bell Wright, America's first million-selling author, who wrote *The Winning of Barbara Worth*. He lived for a while in Redlands.

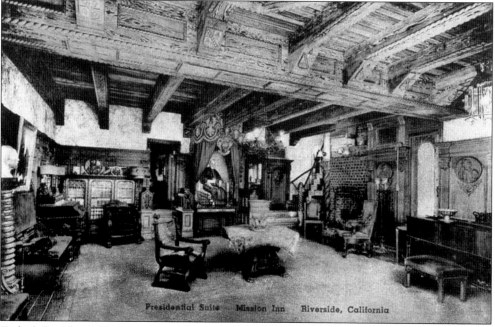

Today's Presidential Lounge, a popular Mission Inn bar, once was the hotel's Presidential Suite, as seen here. Theodore Roosevelt slept here in May 1903. Richard Nixon married Pat in front of the fireplace on June 21, 1940. Ronald Reagan and his wife, Nancy, honeymooned at the inn on March 4, 1952.

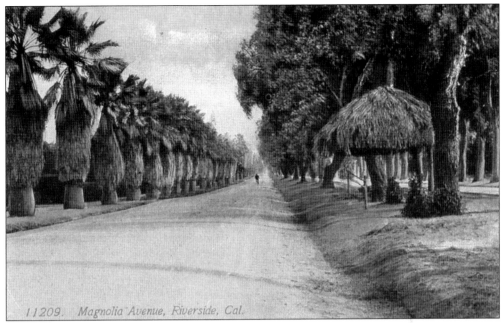

11209. Magnolia Avenue, Riverside, Cal.

Magnolia Avenue, today one of Riverside's busiest streets, was a pastoral country road in March 1910, when this postcard was sent by a visitor who wrote, "Just a note to say we are fine & dandy. Glorious weather." Horse-drawn trolleys on Magnolia would stop for passengers at thatch-covered huts like this one.

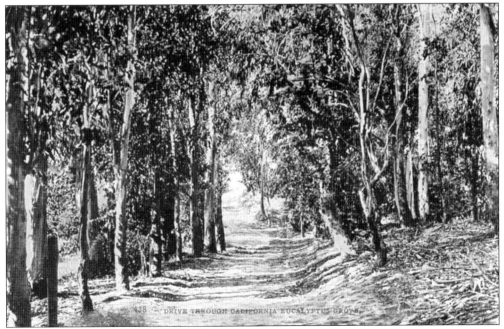

438 – DRIVE THROUGH CALIFORNIA EUCALYPTUS GROVE

Eucalyptus has been one of the heady perfumes of Southern California since ancient times. Inland Empire valleys abound with the fragrant trees. This 1910 postcard, sent from Riverside, is titled "Drive Through California Eucalyptus Grove." On this narrow path, the "drive" most likely would have been by horse and buggy.

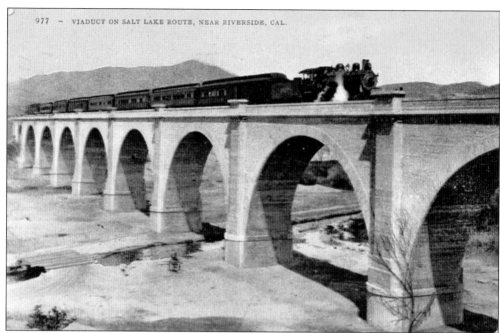

The Union Pacific Railroad's Salt Lake Route, connecting Los Angeles and Salt Lake City, Utah, included a stop in Riverside as well as Las Vegas, Nevada. The Riverside depot was built in 1904. This 1909 postcard shows the train crossing what was billed at the time as the world's largest concrete viaduct near Riverside.

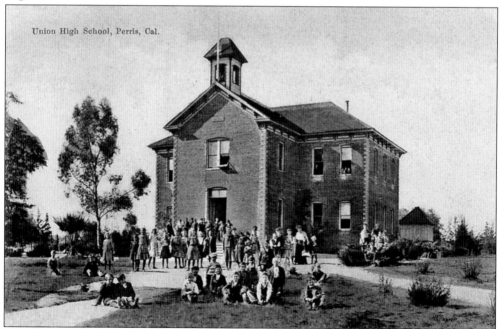

Perris, southeast of Riverside, is an 1880s railroad town named after pioneer railroad builder Fred T. Perris. This 1908 postcard shows the town's high school. Today Perris is the "Skydiving Capital of America," favored by jumpers because of wide clearances around its airport. Popular Lake Perris is nearby.

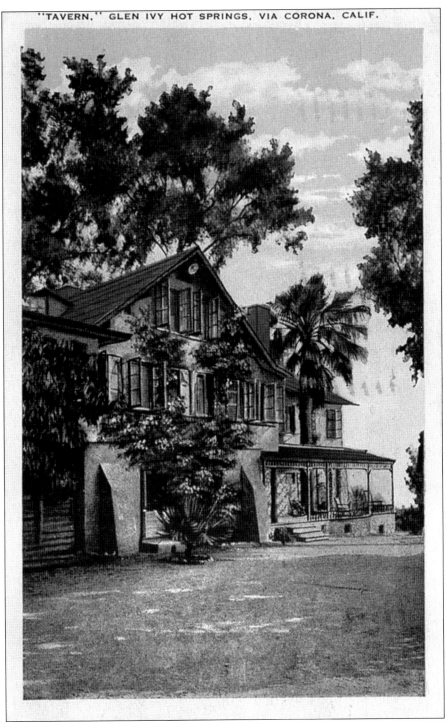

A 1936 postcard advertises Glen Ivy Mineral Hot Springs in Corona, southwest of Riverside, as an "ideal place to recuperate," with "Hot Mineral Baths, Scientific Massage, Warm Sulphur Plunge, Modern Tavern." The still-active resort has pampered many luminaries, including U.S. presidents Herbert Hoover and Ronald Reagan.

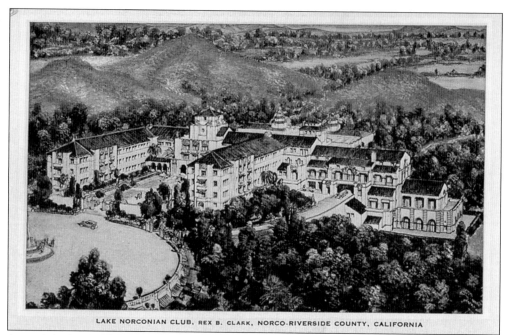

LAKE NORCONIAN CLUB, REX B. CLARK, NORCO-RIVERSIDE COUNTY, CALIFORNIA

An artist's sketch of the Norconian Resort Supreme appears on a 1927 promotional postcard circulated by developer Rex Clark. The Norconian opened in splendor in 1929 in rural Riverside County but soon failed, a victim of the Depression. During its brief heyday, stars such as Greta Garbo and Clark Gable visited.

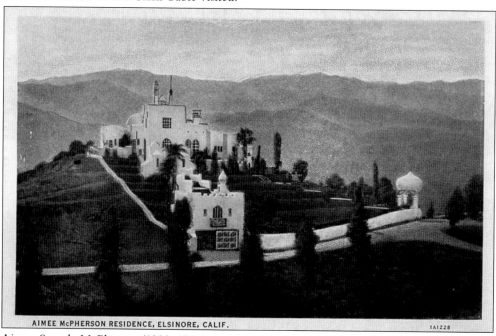

AIMEE McPHERSON RESIDENCE, ELSINORE, CALIF. 1A1228

Aimee Semple McPherson (1890–1944) was an immensely popular Southern California–based evangelist and the founder of the worldwide Foursquare Gospel Church. In 1929, she built a sumptuous castle retreat for herself in Lake Elsinore in Riverside County. Locals still speak of it as "Aimee's Castle."

42

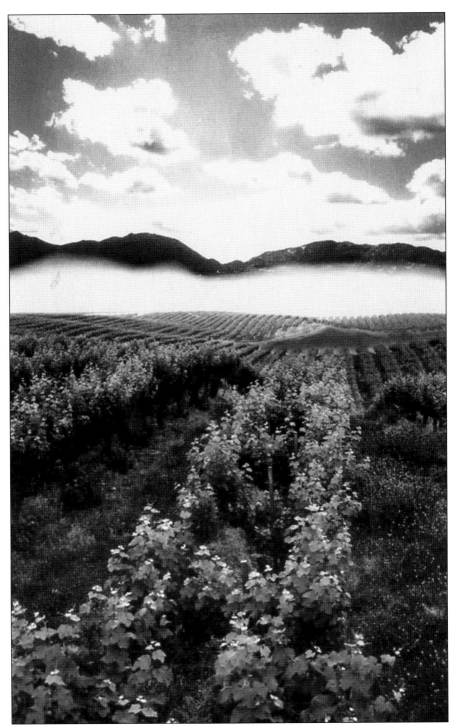

Temecula, south of Riverside near the San Diego County border, is California's booming new wine country, with more than two dozen wineries, many of them recently constructed and palatial. This postcard shows Callaway Vineyard and Winery, one of Temecula's old-timers, founded in 1969 and today famous for its chardonnay.

Built in 1912, the First National Bank of Temecula remained for generations the most imposing building in town. Today Temecula's Old Town district is a lively tourist destination thronged with shops, art galleries, antique stores, and cafes. The Bank, as it now is called, is a busy Mexican restaurant.

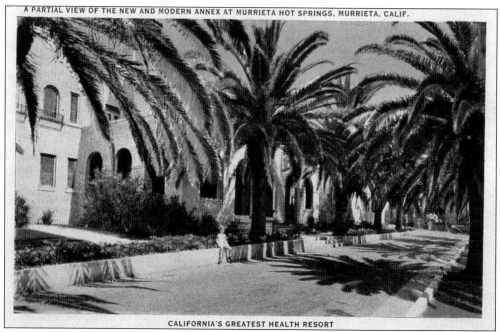

A PARTIAL VIEW OF THE NEW AND MODERN ANNEX AT MURRIETA HOT SPRINGS, MURRIETA, CALIF.

CALIFORNIA'S GREATEST HEALTH RESORT

Murrieta Hot Springs in Murrieta, near Temecula, is billed as "California's Greatest Health Resort" on this postcard of the late 1920s. The card was sent by a gentleman who evidently was a believer. He wrote to loved ones in Los Angeles, "Well, today will complete the first week here. All is well. Feeling fine."

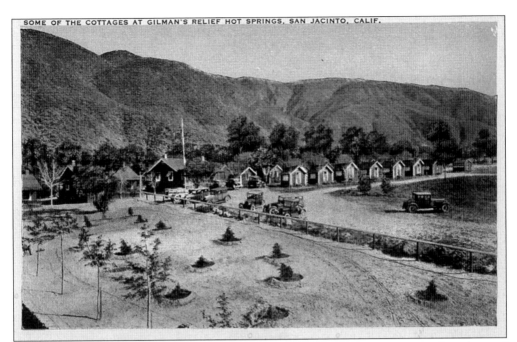

SOME OF THE COTTAGES AT GILMAN'S RELIEF HOT SPRINGS, SAN JACINTO, CALIF.

The arid regions of Riverside County southwest of the San Jacinto Mountains have boasted many health resorts over the years, including Soboba Springs, Eden Hot Springs, and Gilman's Relief Hot Springs. The latter was developed in the 1880s in San Jacinto. Today a major Scientology headquarters is located near the site.

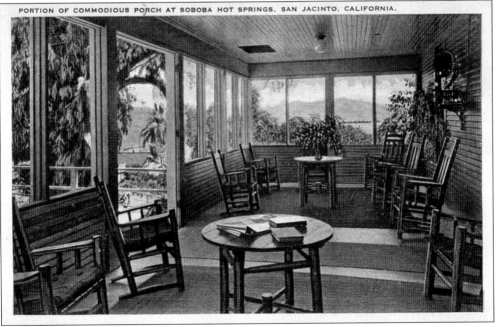

PORTION OF COMMODIOUS PORCH AT SOBOBA HOT SPRINGS, SAN JACINTO, CALIFORNIA.

This postcard shows the "commodious porch" where health seekers at the Soboba Springs spa could convalesce, or at least relax. Today Soboba Springs draws a different crowd. It is the site of the popular Country Club at Soboba Springs, as well as the Soboba Casino, which is owned by the Soboba Band of Mission Indians.

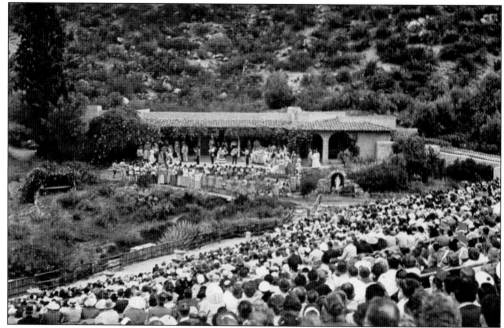

The Ramona Pageant, California's official state outdoor play, has been staged each spring since 1923 in the Ramona Bowl Amphitheatre, set in the hills of Hemet in Riverside County. Originally, spectators sat on rocks and dirt to view the production, but permanent seating, restrooms, and stage sets were built starting in the late 1920s.

The Ramona Pageant is a large-cast musical extravaganza that tells the story of how California evolved from three colliding cultures: Native American, Mexican, and European. At the center of the story are the doomed lovers Ramona, a senorita, and Alessandro, a Native American sheepherder.

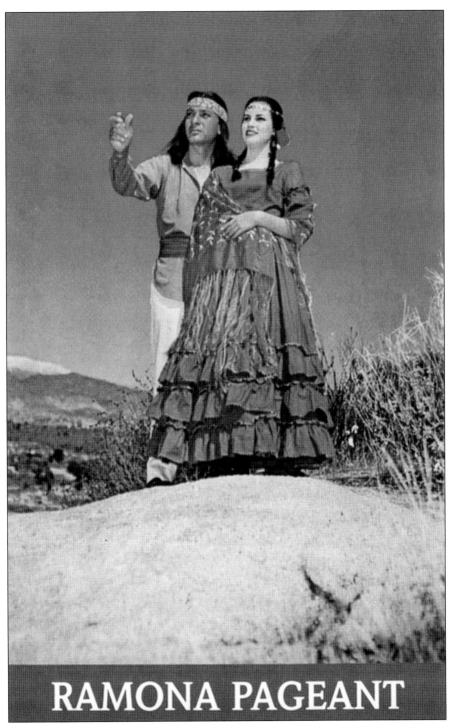

RAMONA PAGEANT

A young Raquel Welch, then named Raquel Tejada, starred with Maurice Jara in the 1959 production of Hemet's Ramona Pageant. Welch, a Golden Globe winner for *The Three Musketeers*, is not the only notable to have handled the title role. Academy Award–nominee Anne Archer (*Fatal Attraction*) played Ramona in 1969.

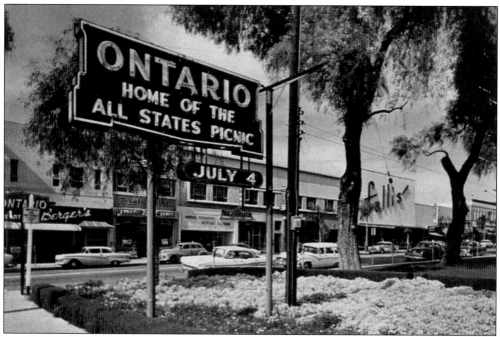

The postcard tour returns to San Bernardino County and its West Valley cities, among which Ontario is the largest. Ontario gained fame for its 2-mile-long All States Picnic on Euclid Avenue, starting in 1939. Today Ontario hosts an international airport and the West's largest single-story shopping mall, Ontario Mills.

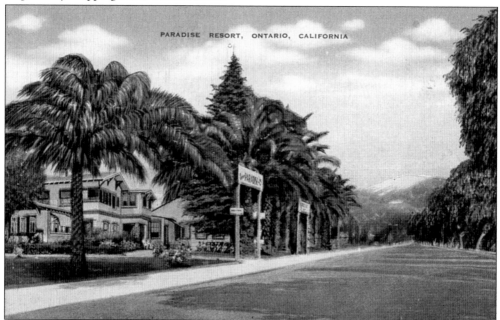

Ontario's Paradise Resort was a quirky spa favored by nudists, atheists, vegetarians, and other free thinkers. It was a mainstay on South Euclid Avenue from 1922 until the mid-1950s. A caption on the back of this 1948 postcard says, "Ontario is free from damp sea fogs and possesses a health-giving, invigorating climate."

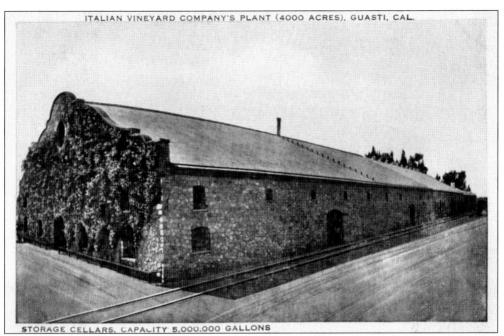

ITALIAN VINEYARD COMPANY'S PLANT (4000 ACRES), GUASTI, CAL.

STORAGE CELLARS, CAPACITY 5,000,000 GALLONS

In 1900, Secondo Guasti established the Italian Vineyard Company in a portion of Ontario that came to be known as Guasti. The storage cellars, seen here, held five million gallons of wine. In time, Guasti evolved into a complete winery village, with its own post office, stores, and restaurants, as well as homes.

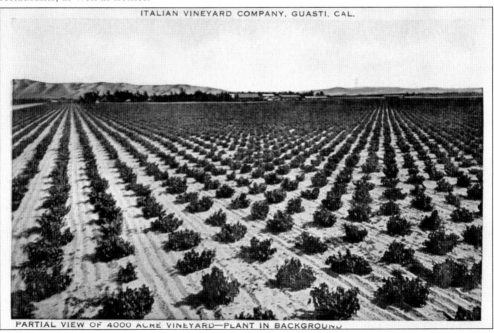

ITALIAN VINEYARD COMPANY, GUASTI, CAL.

PARTIAL VIEW OF 4000 ACRE VINEYARD—PLANT IN BACKGROUND

The Cucamonga Valley is California's oldest wine country, dating to 1838. At its peak, during the 1940s, the region boasted 60 wineries and 45,000 acres of planted grapes, more than Napa Valley and Sonoma Valley combined. The 4,000-acre Italian Vineyard Company vineyard, seen here, was the world's largest.

49

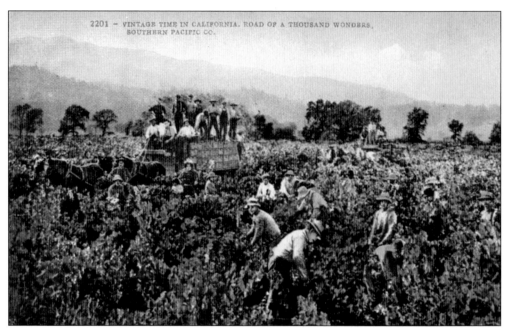

Today's Rancho Cucamonga, north of Ontario, is a triumvirate of three old wine towns: Cucamonga, Etiwanda, and Alta Loma. The region's three remaining wineries—Joseph Filippi Winery and Rancho de Philo, both in Rancho Cucamonga, and Galleano Winery in Mira Loma—are popular stops for tourists and wine lovers.

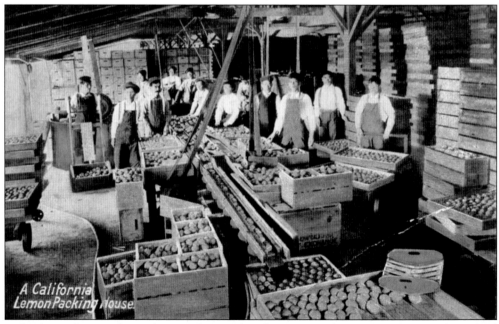

A California Lemon Packing House.

Upland was famous for its lemons during the glory years of citrus growing in the Inland Empire. The city still hosts an annual Lemon Festival each spring. This c. 1900 postcard, sent to Pennsylvania, is inscribed: "I was thinking you would like a few lemons, so I thought I would send you a few."

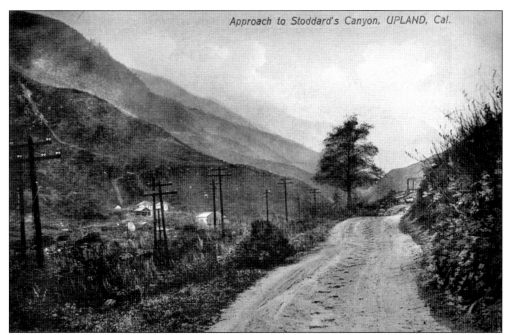

Stoddard's Camp was a popular resort built in 1886 in a foothill canyon north of Upland. There were cabins, picnic tables, and a dance pavilion. It was called "the Niagara Falls of California" because honeymooners favored it. Time and wildfire have obliterated the resort, but the place is still called Stoddard Canyon.

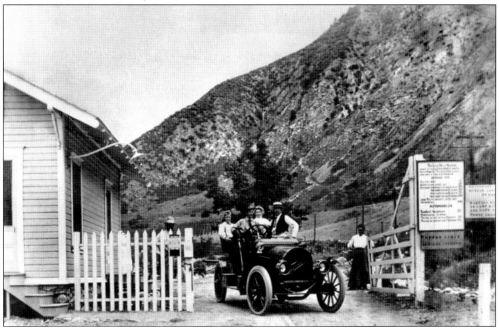

A party of motorists stops for a picture in about 1910 at the ticket gate for the old toll road into San Antonio Canyon above Upland. The San Antonio Water Company charged 10¢ per person, 25¢ per horseback rider, or 50¢ per automobile. The scene is not far from today's San Antonio Dam, built in 1956.

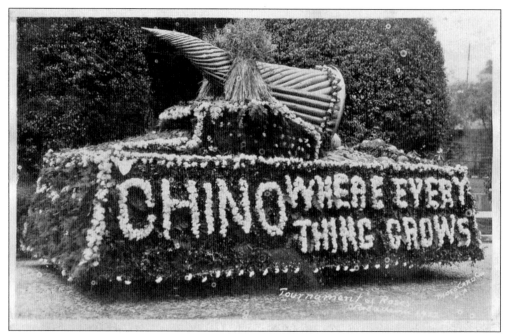

Chino, in the southwest corner of San Bernardino County, was founded in 1910. It entered this cornucopia-topped float in the 1922 Rose Parade in Pasadena. "Where Everything Grows" is the official city motto. Chino eventually became famous for its cattle and dairy industries, as well as its agriculture.

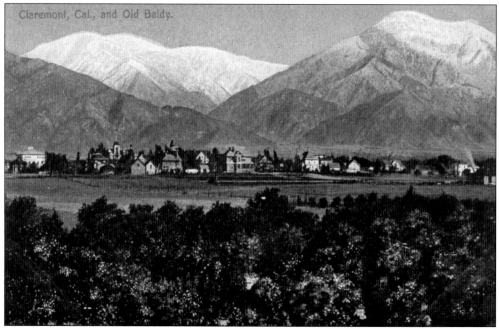

Founded in 1887, Claremont was still a small settlement when this dawn-of-the-20th-century postcard was minted. Claremont, famous for its prestigious Claremont Colleges, is in Los Angeles County, but geographically, it is part of the Inland Empire. It is on the Inland Empire side of the hills that divide the Inland Empire and the Los Angeles basin.

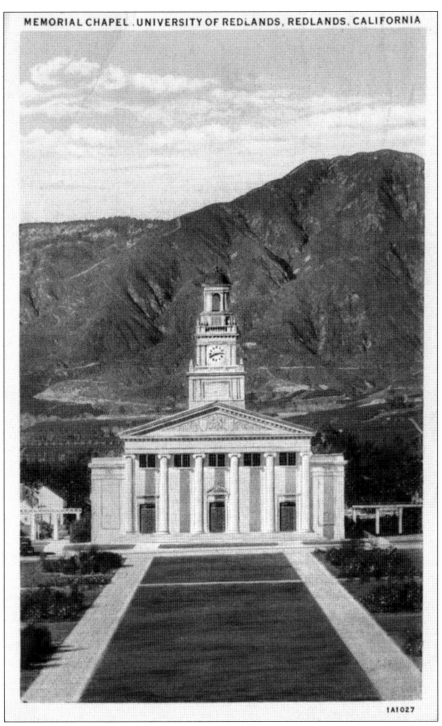

MEMORIAL CHAPEL, UNIVERSITY OF REDLANDS, REDLANDS, CALIFORNIA

1A1027

Now the tour visits Redlands and other East Valley cities. This 1934 postcard shows the Memorial Chapel, still the jewel of the University of Redlands campus, backdropped by the San Bernardino Mountains. The university, founded in 1907, spent 2007 celebrating its centennial. The chapel was built in 1927.

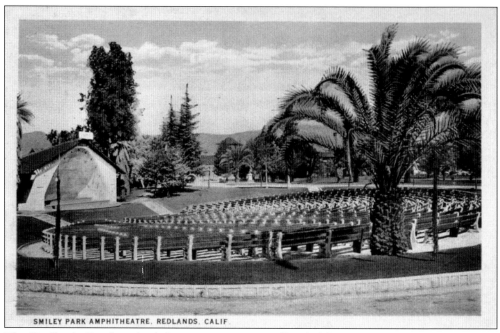

SMILEY PARK AMPHITHEATRE, REDLANDS, CALIF.

The Redlands Bowl evolved from a community effort led by Grace Stewart Mullen, who in 1923 proposed a free summer concert series with professional entertainment. Today the Redlands Summer Music Festival is the oldest, continuously run, free concert series in America. An estimated four million people have attended.

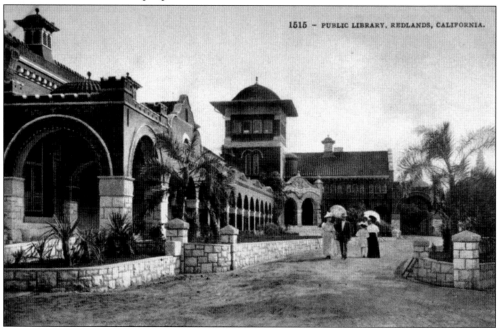

1515 – PUBLIC LIBRARY, REDLANDS, CALIFORNIA.

The Smiley Public Library is a Redlands landmark built in 1894. It was a gift to the city by Albert K. Smiley and his twin brother, Alfred, transplanted New Yorkers who were great benefactors of early Redlands. Their name endures at many locations around the city, including Smiley Park and Smiley Heights.

At one time, Redlands had 40 packinghouses where citrus was processed and shipped under dozens of brand names. Today the Redlands-based Inland Orange Conservancy (www. inlandorange.com) is leading efforts to preserve the remaining groves. The campaign is featured in the documentary *Orange Sunrise* (www.orangesunrise.net).

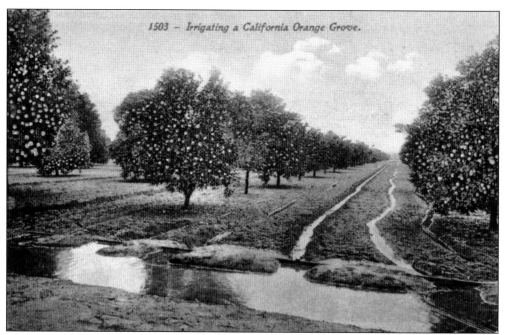

1503 – Irrigating a California Orange Grove.

Both of the largest lakes in the San Bernardino Mountains, Big Bear Lake and Lake Arrowhead, were man-made with the purpose of providing water to irrigate valley citrus orchards. Redlands benefited from Big Bear Lake water, but a lawsuit prevented the removal of water from Lake Arrowhead.

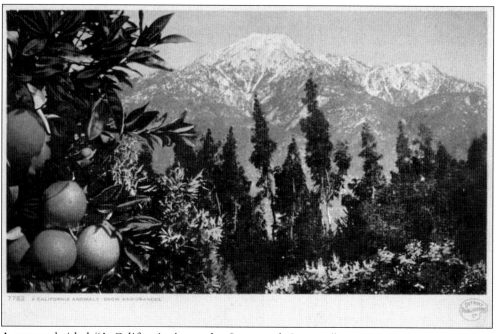

A postcard titled "A California Anomaly: Snow and Oranges" was sent in January 1910 to Newport, New Jersey. The message on the back read, "We are having the usual California weather: Sunny and warm—roses and other flowers so pretty. I have gained a summer and lost a winter. Wish we had this climate in Jersey."

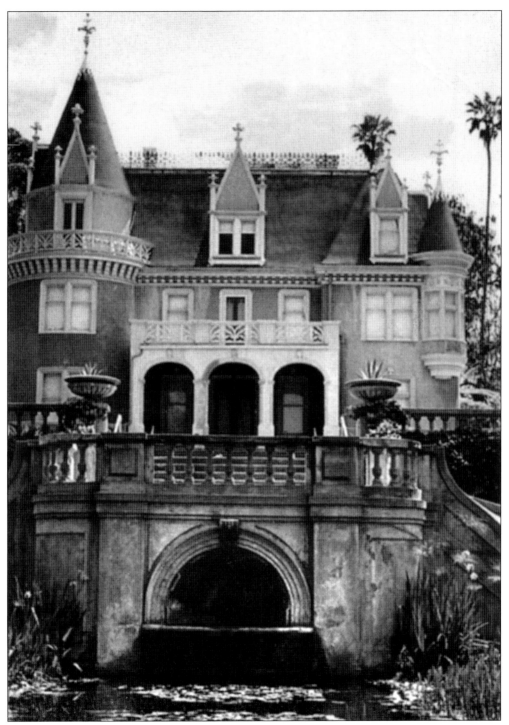

Kimberly Crest, built in 1897, is a Redlands mansion once occupied by the family of J. Alfred Kimberly, cofounder of the Kimberly-Clark paper products company. Today the Kimberly Crest House and Gardens is a popular tourist attraction and venue for weddings and other events throughout the year.

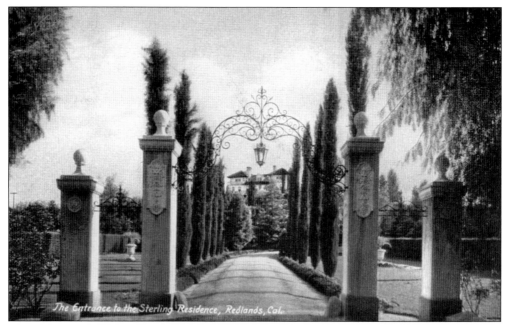

The Entrance to the Sterling Residence, Redlands, Cal.

From its founding in 1881, Redlands has always been famous for its stately homes. The community was developed by wealthy Easterners who built winter homes and planted citrus groves here. This 1909 postcard shows the residence of Edward Canfield Sterling, a St. Louis businessman who relocated to Redlands.

Mt. San Bernardino from Redlands, Cal.

The centerpiece of this view from Smiley Heights in Redlands is the enormous Burrage Mansion, the 28-room winter house of Standard Oil tycoon Albert Burrage. It is one of those classic Inland Empire views that shows citrus groves heavy with ripened fruit in the foreground and snow-capped mountains in the distance.

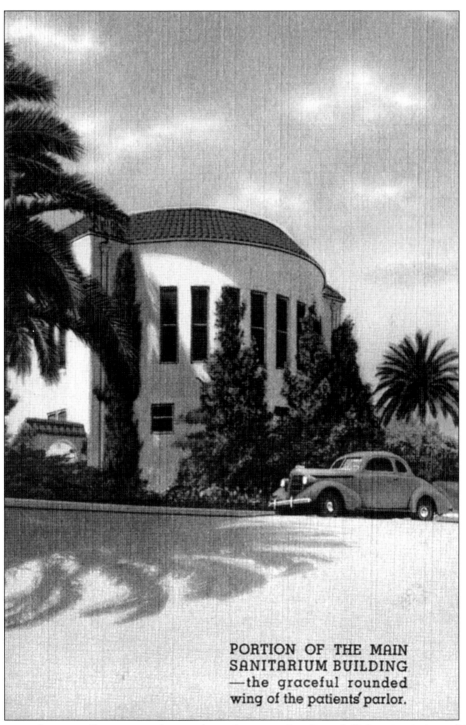

PORTION OF THE MAIN
SANITARIUM BUILDING
—the graceful rounded
wing of the patients' parlor.

Loma Linda originally was named Mound City because of a solitary hill that rises in its middle.
Ellen G. White, founder of the Seventh-day Adventist church, directed denomination officials
to purchase the property and develop a hilltop health resort here. She had received a vision, she
said, foretelling its success.

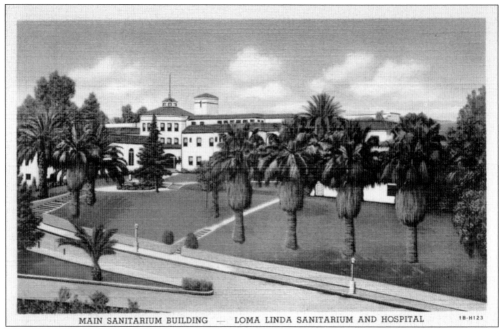

MAIN SANITARIUM BUILDING — LOMA LINDA SANITARIUM AND HOSPITAL 1B-H123

"Come where thousands have found rest, relaxation and health," says this 1930s postcard of Loma Linda Sanitarium, which opened in 1905 and gained a national reputation as a health center. It was the precursor to today's world-famous Loma Linda University Medical Center, which opened a few blocks away in 1961.

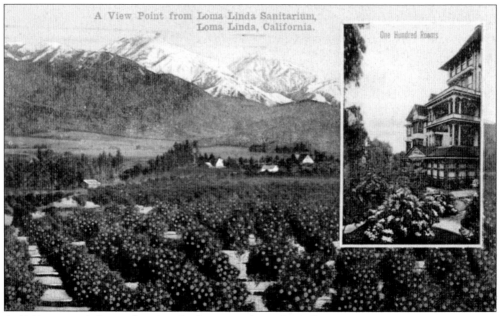

A 1913 postcard shows the view looking out from the hilltop Loma Linda Sanitarium. The inset image advertises "One Hundred Rooms." The caption on the back says, "With the Compliments of the Loma Linda Sanitarium. A Charming Health Resort, amid some of Earth's most inspiring scenery and delightful climate."

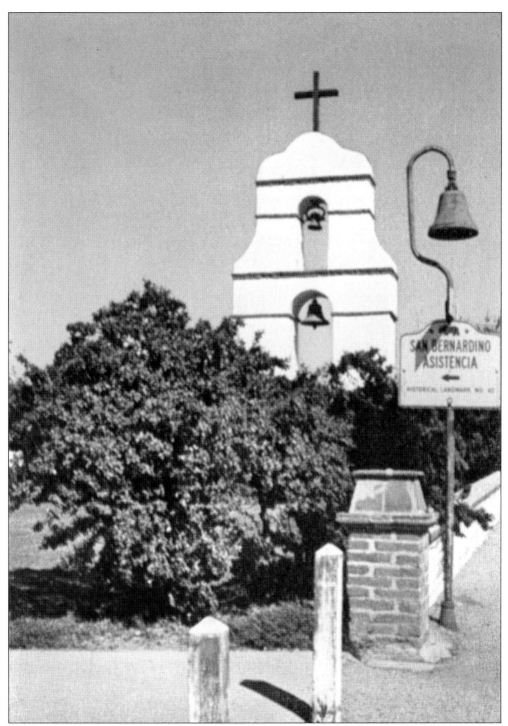

The so-called San Bernardino Asistencia between Loma Linda and Redlands is actually a 1930s-era reproduction of the San Gabriel Mission outpost that was built here in 1819, not long after the region was first explored by Europeans. Today the Asistencia is a popular tourist site and venue for weddings and other events.

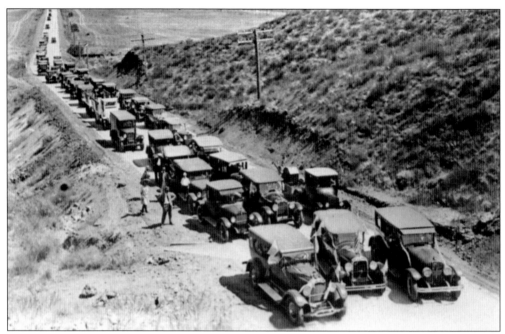

Automobiles of the day line the roadway in Yucaipa on July 23, 1925, to mark the grand opening of the new Highway 99 extension linking Redlands and Beaumont. Automobilists, as they were called, had reason to celebrate. Now they could drive easily between the East Valley and the San Gorgonio Pass.

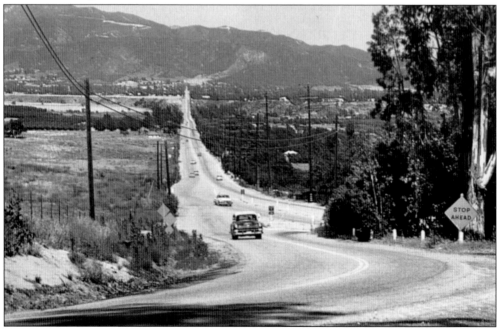

It was not long ago that Yucaipa's main drag, Yucaipa Boulevard, was still mostly a country road. This card is postmarked 1971. Today Yucaipa is exploding with growth, like much of the Inland Empire. Yucaipa Boulevard no longer looks like this. It is lined from end to end with new development.

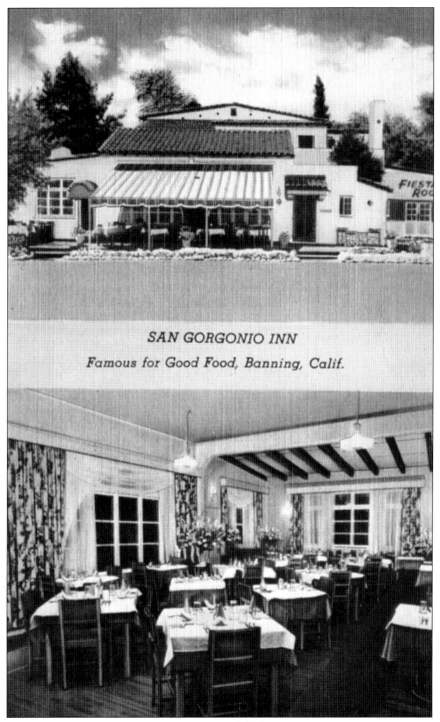

SAN GORGONIO INN
Famous for Good Food, Banning, Calif.

This postcard shows exterior and interior views of the historic San Gorgonio Inn in Banning. Built in 1883, the original inn was a popular stagecoach stop. It was destroyed by fire in 1920 but was quickly rebuilt. It became a favorite rest stop for travelers between Los Angeles and Palm Springs.

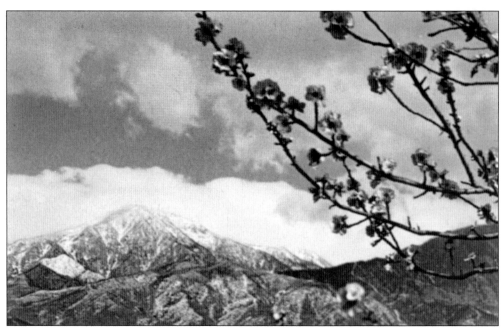

Naturally, the Inland Empire grows nuts as well as fruits. San Gorgonio Pass almond growers helped form the 1910 cooperative that became Blue Diamond Growers, the world's largest tree-nut processing and marketing company. This postcard shows almond trees in blossom, with Mount San Gorgonio as the backdrop.

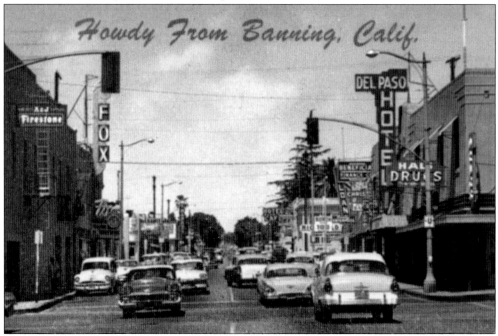

Wyatt Earp once drove stagecoaches through the San Gorgonio Pass outposts of Beaumont and Banning. Later the two towns became important railroad stops. Today both are experiencing rapid commercial and residential growth. And both remain popular stops for travelers between the San Bernardino and Coachella Valleys.

Two

THE MOUNTAINS

There are four distinct, adjoining mountain ranges in the Inland Empire: the San Gabriels, the San Bernardinos, the San Jacintos, and the Santa Rosas. Together they form a curved bulwark that separates the valley cities from the great deserts to the north and east. The postcard tour will begin with a brief visit to the San Gabriel Mountains, which straddle Los Angeles and San Bernardino Counties, extending their eastern flanks into the Inland Empire. Then the tour climbs up the Rim of the World Highway out of San Bernardino and stops at Lake Arrowhead, Running Springs, Big Bear Lake, and other resort communities of the San Bernardino Mountains. After the west-to-east sojourn along the Rim of the World, the tour descends on the eastern side of the range and then climbs again, this time into the San Jacintos, which curve into Riverside County, followed by the Santa Rosas, which continue into Imperial County. The mountain tour concludes at the charming resort town of Idyllwild and its environs in the San Jacintos.

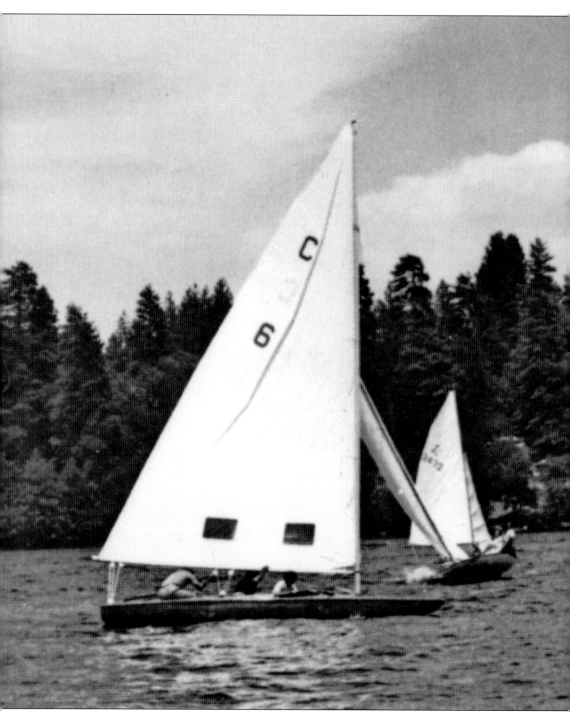

The Inland Empire's mountains are famous for beautiful resorts, but this was not always the case. Once, in fact, there were no lakes at all, and certainly no ski resorts. In ancient times, the mountains were a summer home for indigenous tribes. After the arrival of white settlers, beginning in the 1850s, the mountains became dotted with logging camps, where timber was harvested. After the discovery of gold near Big Bear Lake, mining camps were built. One

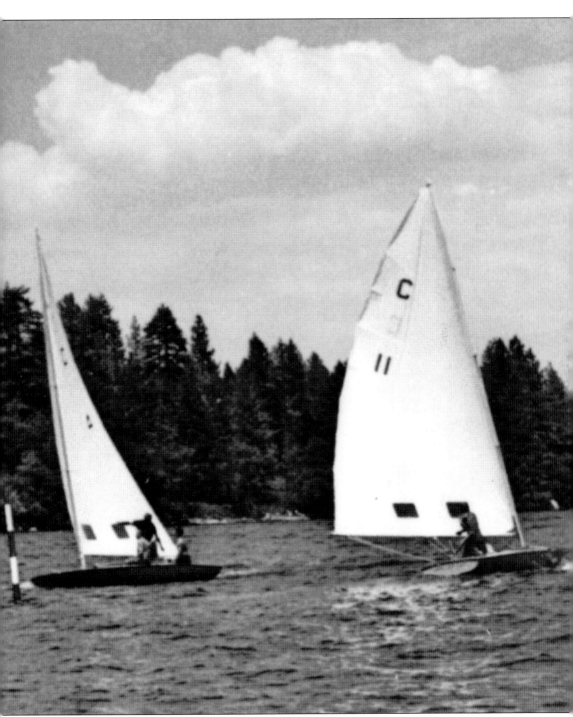

of these, the now-extinct Belleville, rivaled San Bernardino in size and lost by a single vote in its bid to become the county seat. In the 1870s, when the valley citrus industry boomed, mountain streams were dammed to create water reservoirs for irrigation. These evolved into today's resorts at Lake Arrowhead (seen here) and Big Bear Lake. Other man-made lakes, including Lake Gregory and Silverwood Lake, were created later.

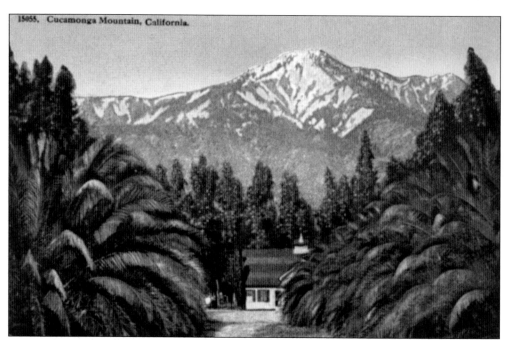

15055. Cucamonga Mountain, California.

The San Gabriel Mountains extend west to east from Los Angeles County into San Bernardino County. The eastern peaks are the range's tallest and best known. Cucamonga Peak, distinctive for its flattened top, is 8,859 feet in elevation. Nearby peaks, similar in elevation, include Telegraph Peak and Ontario Peak.

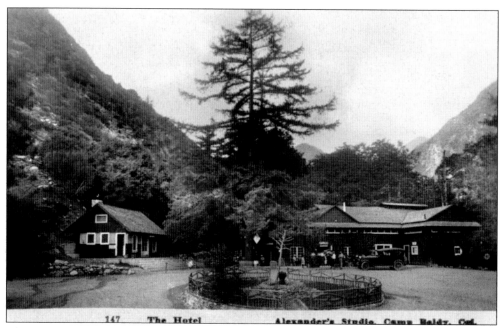

147 The Hotel Alexander's Studio, Camp Baldy, Cal.

The tallest peak in the San Gabriel range is Mount San Antonio, commonly called Mount Baldy or Old Baldy, which is 10,064 feet high. This 1920s postcard shows a rustic hotel at Camp Baldy located partway up the mountain. Most of Camp Baldy was destroyed in a 1938 flood. It is the site of today's Mount Baldy Village.

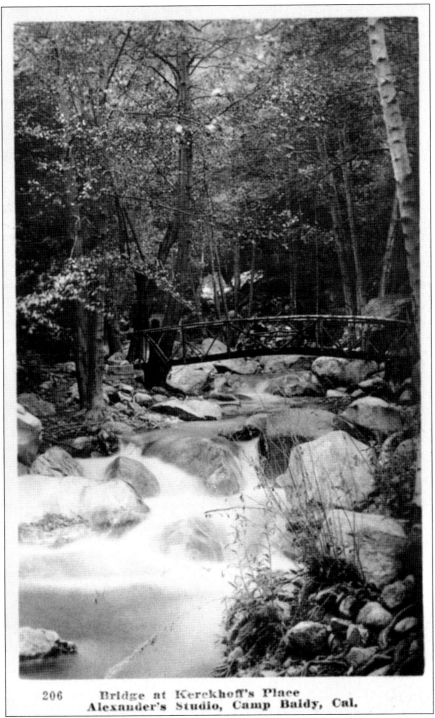

206 Bridge at Kerckhoff's Place
Alexander's Studio, Camp Baldy, Cal.

A bridge near Camp Baldy is seen in this 1920s postcard. Mount Baldy is one of 19 mountains in the world considered holy by the Aetherius Society, whose members believe the peaks are charged with spiritual energy by extraterrestrial Cosmic Masters. The mountain is also home to the Mount Baldy Zen Center, founded in 1972.

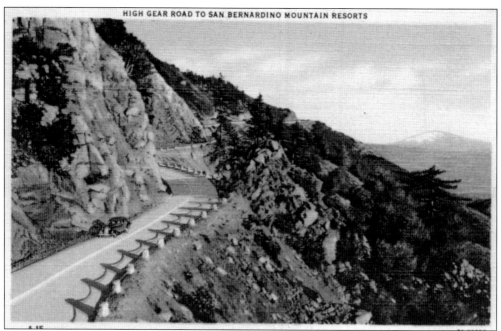

The San Bernardino Mountains are entirely contained within San Bernardino County. The range includes Southern California's tallest peak, Mount San Gorgonio, commonly called Old Greyback, which is 11,502 feet in elevation. The historic first route up the mountain was what is now called Highway 18 north from San Bernardino.

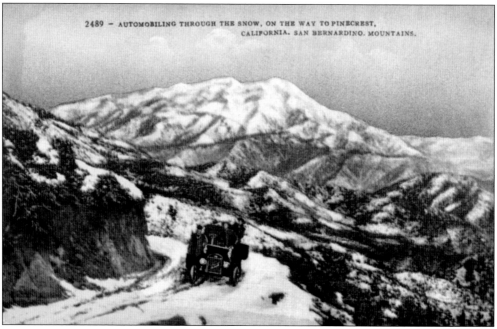

2489 – AUTOMOBILING THROUGH THE SNOW, ON THE WAY TO PINECREST, CALIFORNIA. SAN BERNARDINO. MOUNTAINS.

First it was a path worn by indigenous tribes. Then it was a logging road dug by Mormon settlers. Later it was a stagecoach route. Finally, in 1911, the road between San Bernardino and the mountains was opened to automobiles. A postcard from that year shows a motorcar struggling through snow on the way to Pinecrest near Crestline.

70

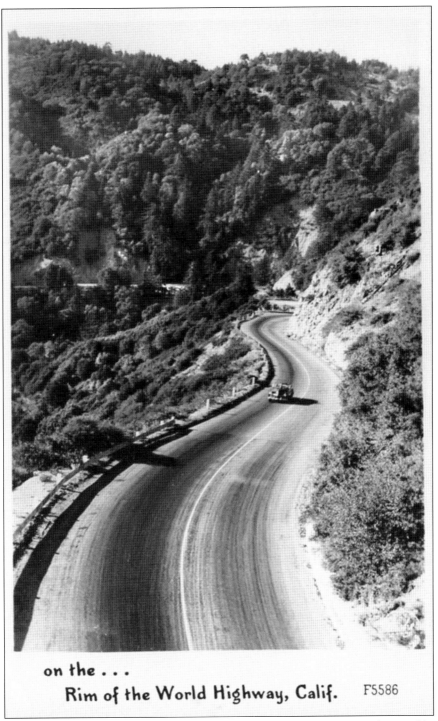

on the . . .
Rim of the World Highway, Calif. F5586

This postcard of the Rim of the World Highway, which opened in 1915 and was widened in the 1930s, was sent all of 85 miles, from Lake Arrowhead to Hollywood, on a hot August day in 1951. The sender wrote, "Elsie & Minnie are taking sunbaths in the afternoon. It is very warm up here. You have hot weather, too."

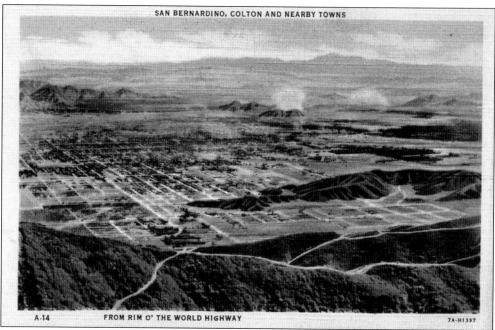

A-14 FROM RIM O' THE WORLD HIGHWAY 7A-H1397

The San Bernardino Valley still appears lightly settled in this 1930s postcard titled "San Bernardino, Colton and Nearby Towns from Rim O' the World Highway." The 100-mile route along the summit of the San Bernardinos opened in 1915. By 1933, it was termed a "High Gear Road" because of improvements allowing for greater speeds.

Crestline is the westernmost town in the San Bernardino Mountains, just minutes by car from San Bernardino. Its accessibility makes it a popular choice for quick mountain getaways. Upper Crestline is close to Highway 18. Lower Crestline, seen here, surrounds man-made Lake Gregory, a public recreational lake.

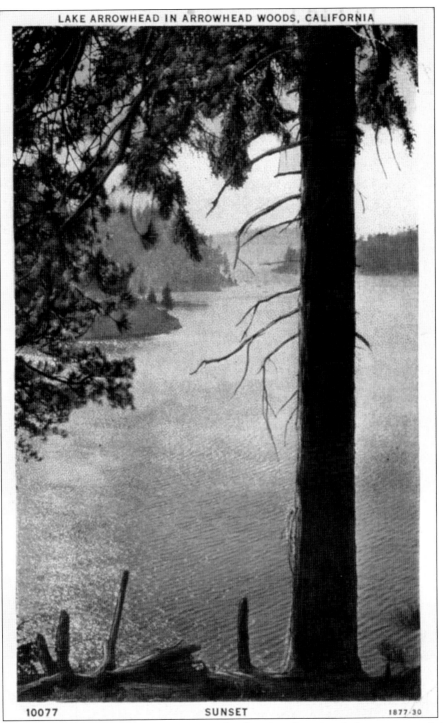

10077 SUNSET 1877-30

In this 1937 postcard, a visitor to Lake Arrowhead writes from her lodge accommodations, "Was over to the lake today and many miles thru the mts. Everything is so grand up in this cottage overlooking San Bernardino—its lights twinkle like stars—millions of stars—every window you look from, the view is grand."

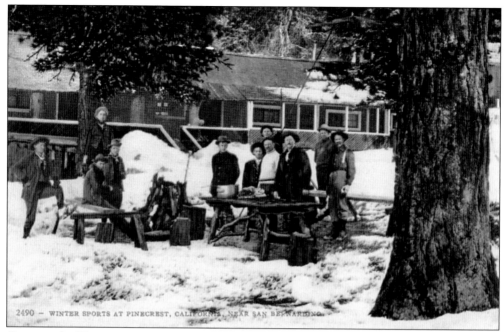

Guests at the Pinecrest Resort, near Lake Arrowhead, are seen on a postcard sent in June 1917 to New Haven, Connecticut. The message on the back reads, "Just to let you know I'm well and happy. Pretty hot here afternoon time but lovely night and morning." Today Pinecrest is a church retreat and conference center.

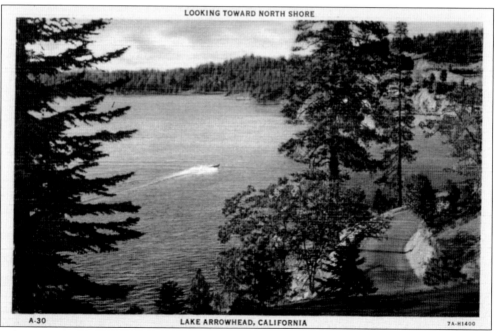

Lake Arrowhead, only 80 miles from Los Angeles, has always been a haven for Hollywood entertainers. Many have had second homes at the lake, including Charlie Chaplin, Shirley Temple, Liberace, Doris Day, Rock Hudson, Herb Albert, Dick Clark, Priscilla Presley, Patrick Swayze, Mark Harmon, John Candy, and Heather Locklear.

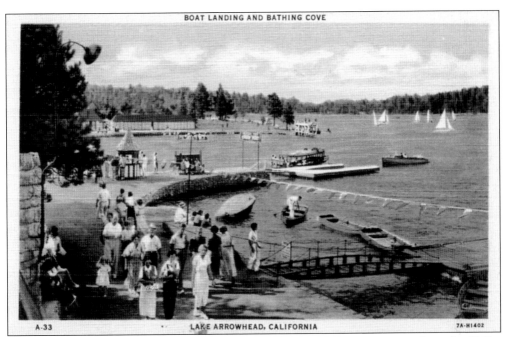

A-33 LAKE ARROWHEAD, CALIFORNIA 7A-H1402

Lake Arrowhead Village, on the lake's south side, has been a roaring scene since the 1920s. According to local legend, billionaire industrialist and filmmaker Howard Hughes would land his seaplane on Lake Arrowhead and check in, with a starlet or two, at the waterside Saddleback Inn, which is still in operation today.

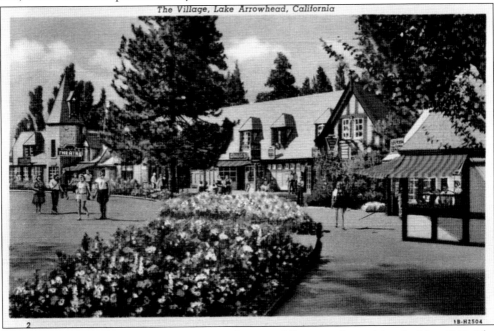

The Village, Lake Arrowhead, California

Lake Arrowhead Village is seen in a postcard sent to Minnesota by a visitor in May 1947. The note on the back says, "Very ritzy and beautiful." The original village, constructed in the 1920s, was razed in 1978. Redeveloped in the same style, the village reopened in 1982. It is crowded with visitors year-round.

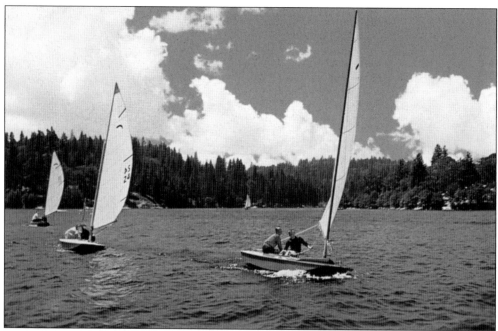

Lake Arrowhead is very deep and thus very blue. Once surrounded by pine trees, it is now surrounded by homes set among the pines, with walkways leading down to waterfront docks and boats. Sailboating is a favorite pastime on the lake, as is fishing. Lake trout, bass, and catfish are the catches of the day.

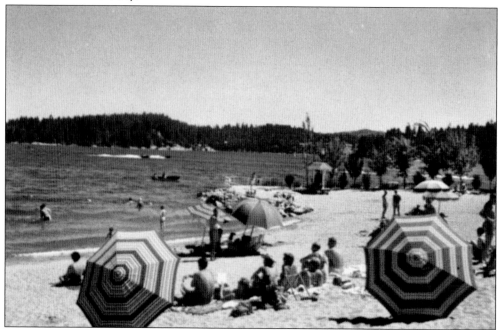

Lake Arrowhead is a private lake, belonging to the homeowners who live around it, but Lake Arrowhead Village, with restaurants and shops, is open to the public. At one time, there was a public beach, as seen in this 1960s postcard. Today, though, excursion boat tours provide the only public access to the lake.

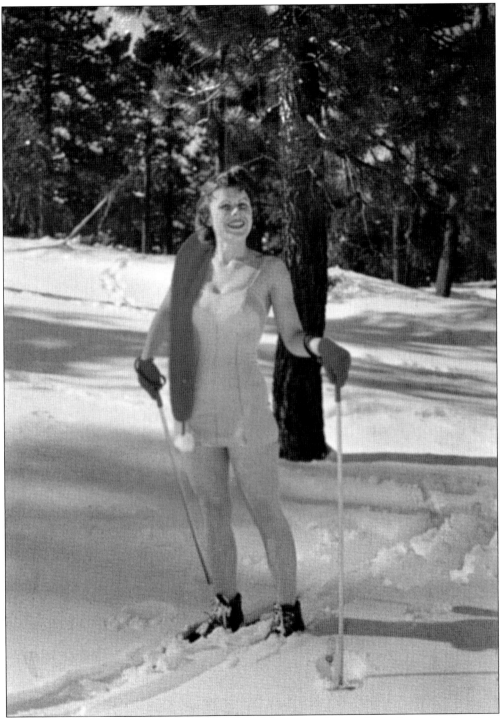

A 1955 promotional postcard shows a bathing beauty on skis, making the point that Lake Arrowhead has the best of both worlds, with plenty of snow and plenty of sunshine. The caption on the back takes a considerable measure of artistic license in declaring it a "typical mid-winter scene" in the San Bernardino Mountains.

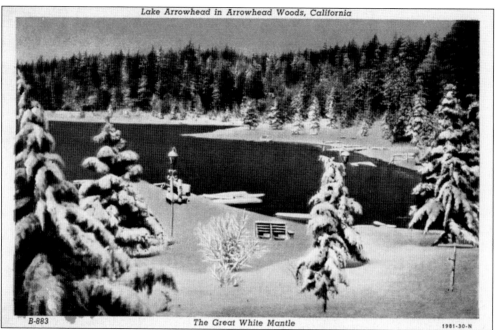

Lake Arrowhead in Arrowhead Woods, California

B-883 The Great White Mantle 1981-30-N

Lake Arrowhead today is lined with lakefront mansions, but in this 1930s view, the shoreline is almost pristine. Fewer than a handful of docks are visible. The printed caption on the back reads, "Only 80 miles from Los Angeles . . . New High Gear Scenic State Highway All the Way . . . LAKE ARROWHEAD."

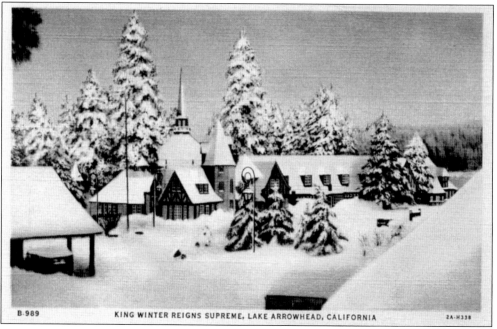

B-989 KING WINTER REIGNS SUPREME, LAKE ARROWHEAD, CALIFORNIA 2A-H338

The title of this postcard is "King Winter Reigns Supreme, Lake Arrowhead, California." It is a bit of an overstatement. Snow can fall 10 months out of the year—July and August are virtually out of the question—but usually snow falls in manageable amounts and melts quickly. Of course, there are exceptions.

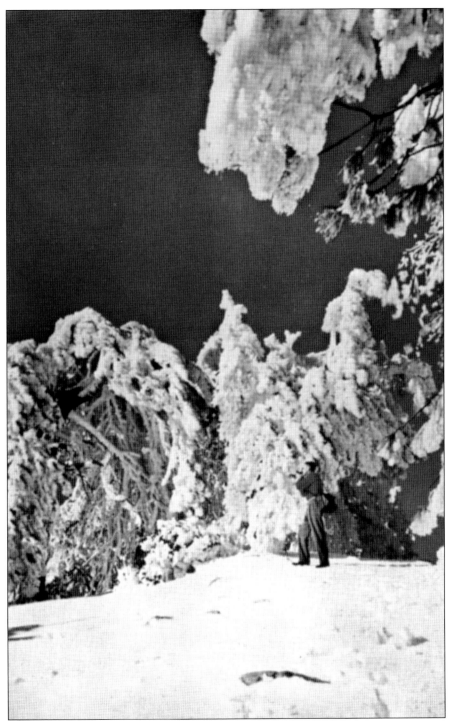

At an elevation of more than 5,000 feet, Lake Arrowhead can receive abundant snowfall during exceptionally wet winters. In this 1950s postcard, a photographer gets to work after a heavy storm. Haste is necessary because Lake Arrowhead boasts more than 300 sunny days a year. Snow in treetops typically does not last long.

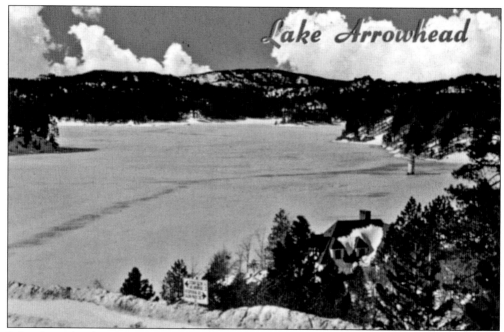

Lake Arrowhead was created at the dawn of the 20th century by damming a crater-like mountain valley with steep sides. It was so steep, in fact, that as a result, Lake Arrowhead is almost 200 feet deep in some locations. Only rarely does it freeze over in winter. The winter of 1949 was one such season.

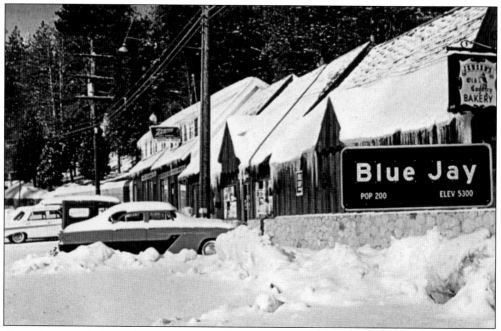

A 1960s postcard shows the community of Blue Jay, on the eastern shore of Lake Arrowhead. The population then was 200, a tenth of what it is today. At one time, Blue Jay had a popular public ice skating rink, and it still is home to the Ice Castle Training Center, where Olympians such as Michelle Kwan have trained.

In 1955, just a few weeks before Disneyland opened in Anaheim, Santa's Village opened in Skyforest near Lake Arrowhead. It became a popular year-round attraction, with rides, shops, and costumed characters, including Santa himself. The park was open every day of the year—except Christmas. Santa's Village closed in 1998.

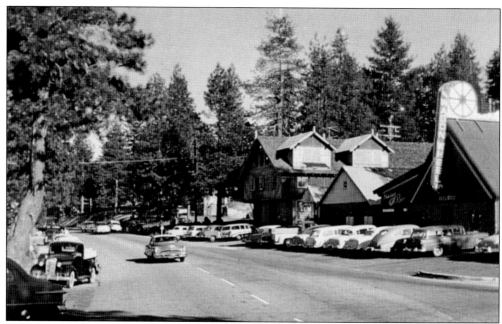

Hunsaker Flats was the site of major logging operations in pioneer days. Timber was felled, cut, and then loaded for transport down the steep City Creek Toll Road to Highland. The toll road evolved to become today's State Highway 330, and Hunsaker Flats grew to become today's Running Springs, located between Lake Arrowhead and Big Bear Lake.

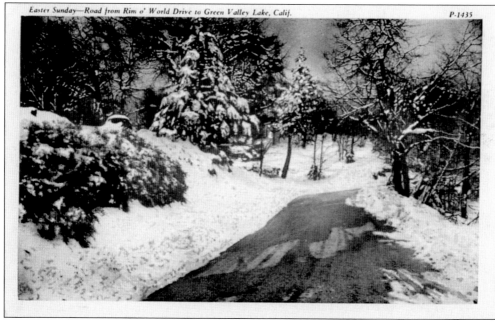

Easter Sunday—Road from Rim o' World Drive to Green Valley Lake, Calif. *P-1435*

Green Valley Lake originally was known as Green Valley, a busy wagon stop on the timber road near Running Springs. When the Rim of the World Highway was constructed, Green Valley found itself bypassed. It responded by building a dam, creating Green Valley Lake and promoting itself as a secluded sportsmen's retreat.

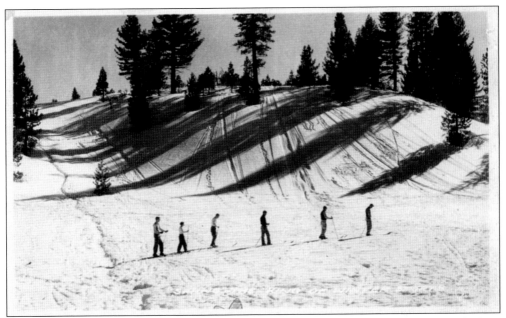

This 1940s postcard shows a ski lesson in progress at Snow Valley, between Running Springs and Big Bear Lake. Snow Valley opened in the 1920s, the first ski resort in the San Bernardino Mountains. Today there are several others, including Bear Mountain, Snow Summit, and Rim Nordic and Green Valley Nordic Ski Areas.

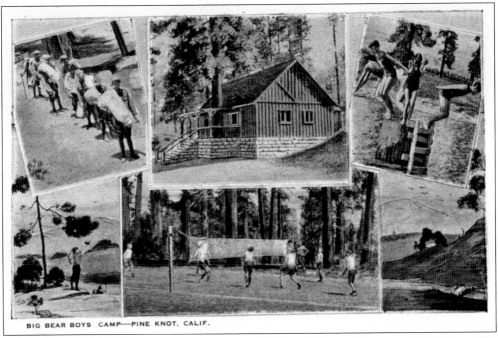

BIG BEAR BOYS CAMP—PINE KNOT, CALIF.

During its early years, the largest settlement at Big Bear Lake was known as Pine Knot. The town was renamed Big Bear Lake in 1938. This 1920s postcard advertises the Big Bear Boys' Camp near Pine Knot. The caption promises, "A season at the Camp will become one of the most delightful memories of a boy's life."

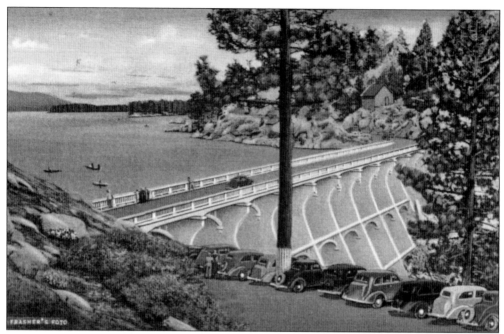

The original dam at Big Bear Lake was built in 1884 to secure a dependable water supply for Redlands-area citrus orchards. The present dam, built in 1912, was 20 feet higher and increased the lake from 1,800 acres to 2,500 acres. The enlarged Big Bear Lake evolved quickly to become a residential and recreational lake.

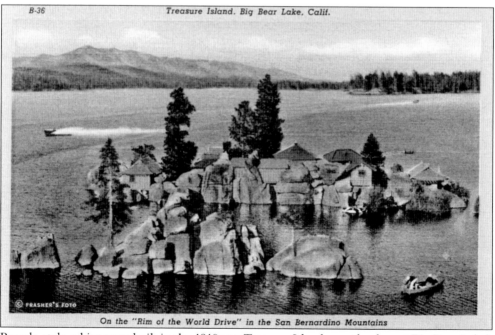

Pagoda-style cabins were built in the 1910s on Treasure Island near the dam at Big Bear Lake's west end. The style was chosen by Maude Garstin, the wife of Bear Valley Mutual Water Company president Herbert Garstin. Her brother lived in China, and the Garstins were frequent travelers there. The cabins still exist today.

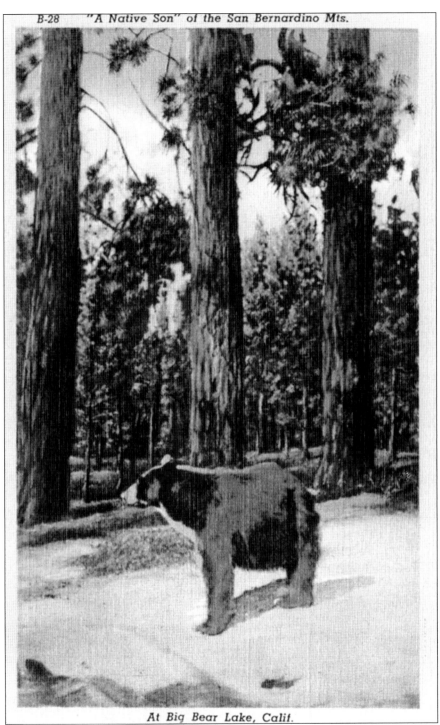

At Big Bear Lake, Calif.

This penny postcard of Big Bear Lake identifies its subject as "A Native Son" of the San Bernardino Mountains. Brown bears like this one are still seen today. The larger grizzly bears, for which the lake and city are named, were hunted to extinction in these mountains. The last sighting was in 1906.

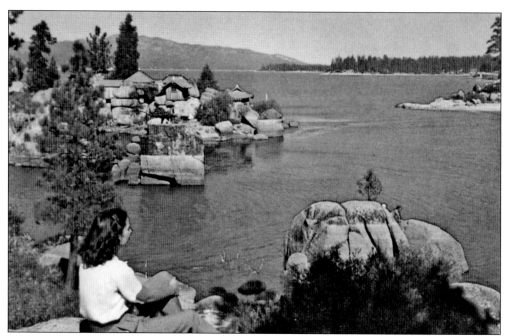

A young lady poses for a glamour shot in this 1940s postcard. She is gazing at Treasure Island near the Big Bear Lake dam. Many movies have been shot at the lake, including *The Call of the North* and *Birth of a Nation*. There is even a scene in *Gone with the Wind* that was shot on a forested wagon road near the lake.

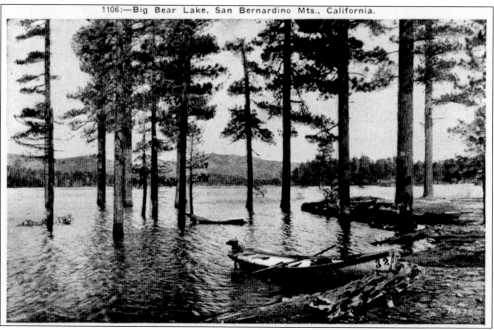

1106:—Big Bear Lake, San Bernardino Mts., California.

Unlike Lake Arrowhead, which is private, Big Bear Lake has always been open to the public. It is one of the busiest recreational lakes in California, especially during the summer months. Because it is a relatively shallow lake situated at an elevation of 8,000 feet, it can freeze over completely in the wintertime.

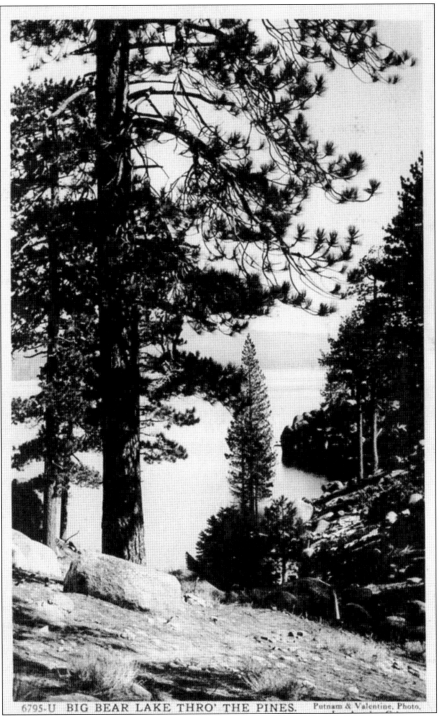

6795-U BIG BEAR LAKE THRO' THE PINES. Putnam & Valentine, Photo.

A postcard titled "Big Bear Lake Thro' the Pines" shows a pristine lake surrounded by little else other than trees. Today, of course, it is dotted with marinas, restaurants, inns and many houses. Among the notables who have had homes here are Lana Turner and Mel Blanc, the voice of Bugs Bunny, Daffy Duck, and Porky Pig.

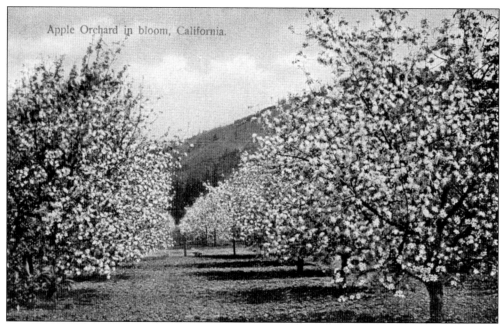

The tour of the San Bernardino Mountains ends with a visit to Oak Glen, a picturesque mile-high village lined with apple ranches located near the eastern terminus of the Rim of the World Highway, not far from Yucaipa. This 1910 postcard shows an Oak Glen apple orchard in full springtime bloom.

The first apple trees in Oak Glen were planted in the 1860s. By the end of the 19th century, the mountain community had become a famous apple country, exporting Rome beauties and other varieties around the world. Tourists still flock to Oak Glen to buy fruit and fresh cider from rustic roadside stands.

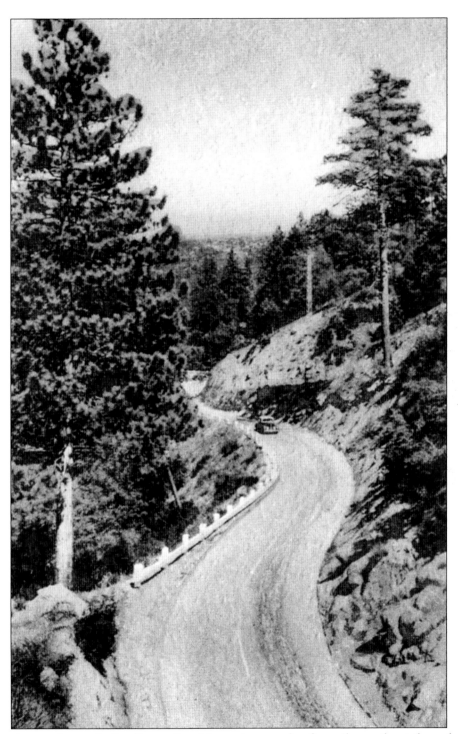

Now the tour leaves the San Bernardino Mountains, travels a few miles southeast through the San Gorgonio Pass, then takes the hairpin road up to Idyllwild, in the San Jacinto Mountains above Palm Springs. The San Jacintos have no ski resorts, so they are minimally developed and pristine, and are favored by hikers and rock climbers.

Idyllwild once was the summer home of the Cahuilla Indians. Tahquitz Peak, seen at center, derives its name from a Cahuilla legend. Tahquitz is a demon imprisoned in the rock. His violent outbursts cause earthquakes and thunderstorms. The peak is also known as Lily Rock because of its bright-white appearance.

Idyllwild has been named one of the "100 Best Art Towns in America." The small community has almost 20 art galleries, featuring the work of 200 local artists. Idyllwild is also home to the prestigious Idyllwild Arts Academy, the only arts-based boarding school in the West and one of only three in the nation.

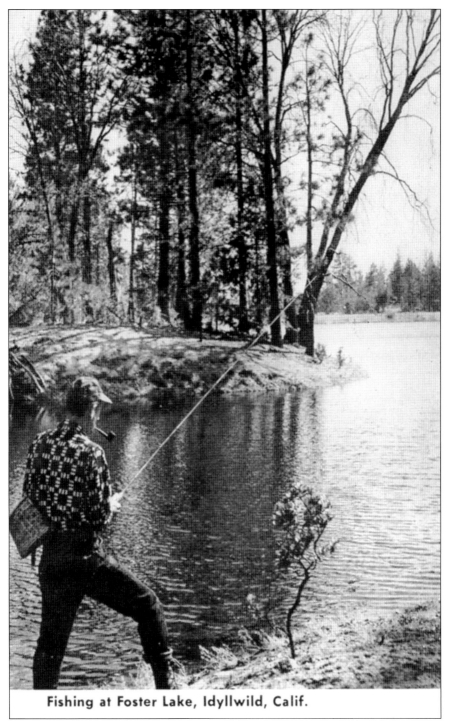

Fishing at Foster Lake, Idyllwild, Calif.

Idyllwild originally was known as Strawberry Valley because of the wild strawberries that grow here. They are especially abundant alongside the creek that runs through town, called Strawberry Creek. The Idyllwild area also has a number of small lakes, including Foster Lake, seen in this 1953 postcard.

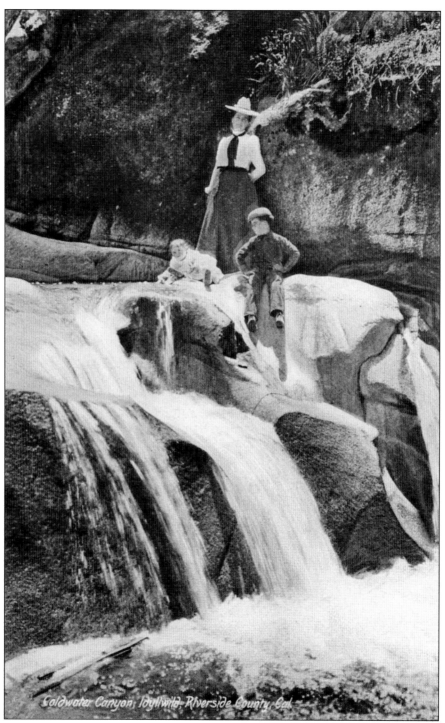

Coldwater Canyon, Idyllwild, Riverside County, Cal.

Idyllwild exerts a charm on people. In the 1960s, it was home to the Brotherhood of Eternal Love, founded by hippie guru Timothy Leary. For generations, water from a spring along Highway 243 has been reputed to have healing powers, and crowds gather every day to fill containers there. This postcard is dated 1909.

Three

THE DESERTS

The Inland Empire has some of the world's most famous desert resorts, including two of California's largest national parks—Death Valley and Joshua Tree—and the vast 1.6-million-acre Mojave National Preserve. Readers will begin their tour by taking the Cajon Pass north from San Bernardino, which climbs between the San Gabriel and San Bernardino Mountains to the High Desert beyond. There the tour stops at Victorville, Apple Valley, Barstow, and the famous ghost town at Calico. Next the tour takes a journey to Death Valley. The tour also visits some of the other communities in the San Bernardino County desert, such as Baker, Needles, and Twentynine Palms. The excursion will then proceed to Riverside County to visit Joshua Tree National Park and the glamorous resort city of Palm Springs. Other stops will be made at Coachella Valley communities such as Indio, Mecca, and Thermal, and then the tour will end at the quirky Salton Sea.

632 Smoke Trees on the Desert

7A-H3624

Every westward-seeking explorer and settler who arrived in the Inland Empire valleys was obliged to traverse the mighty desert to do so. It was a dangerous trek in covered-wagon days, and many lives were lost. Even in the early days of the automobile, motorists usually made the crossing during the cool of night and carried large containers of extra water. But while many people may have considered the desert a necessary evil to be endured, others sought out the desert as their destination of choice. Miners staked claims and built towns. Entrepreneurs established spas and resorts. Generations of visitors have discovered that the desert, far from being stark and featureless, is a land of great beauty and wonder.

The Mormon Rocks in the Cajon Pass are where Mormon explorers from Salt Lake City, Utah, camped on the eve of their discovery of the San Bernardino Valley in 1851. The distinctive, upended appearance of the rocks is the result of ancient seismic activity. The San Andreas Fault passes directly through the canyon.

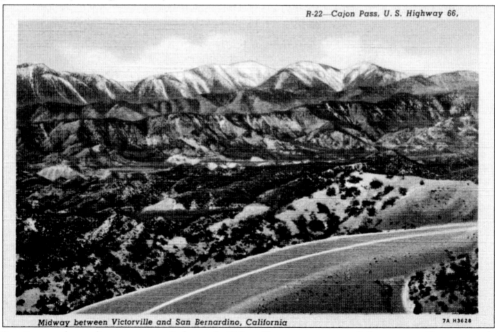

In pioneer days, the wagon road through Cajon Pass was steep and dangerous. Passage took more than a day. Today it is a 20-minute drive. The pass community of Devore is where the mammoth US Festival rock concerts of 1982–1983 led to the construction of today's Glen Helen Pavilion, the nation's largest outdoor amphitheater.

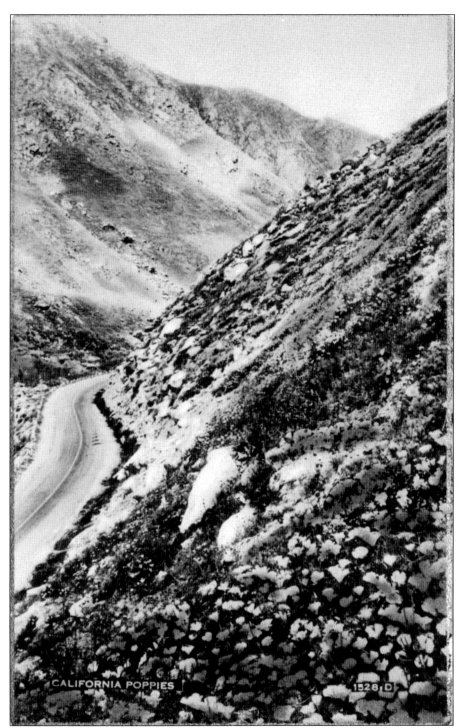

CALIFORNIA POPPIES 1528 D

Poppies, lupines, and other wildflowers are plentiful in the springtime in the High Desert, especially after wet winters. Popular viewing spots are in the Victor Valley, in San Bernardino County, and in its neighbor to the west, the Antelope Valley in Los Angeles County, which hosts the annual California Poppy Festival.

Visitors of long ago enjoy the High Desert poppy fields. Poppies are celebrated around the world ("In Flanders Field" by Canadian poet John McCrae and *Poppy Fields at Argenteuil* by French painter Claude Monet are two examples), but they have gained official stature in California, where they are the state flower.

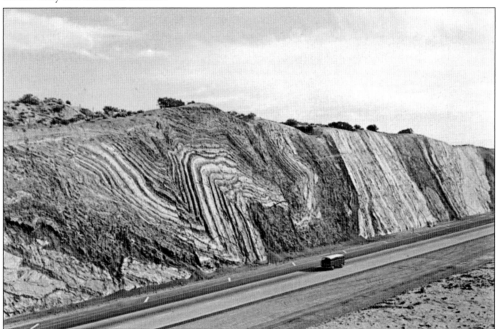

The southern end of the San Andreas Fault snakes its way on a southeasterly course through both San Bernardino and Riverside Counties, terminating at the Salton Sea. Visible here is a deep highway cut west of Victorville that exposes layers of earth tilted and folded by ongoing seismic activity.

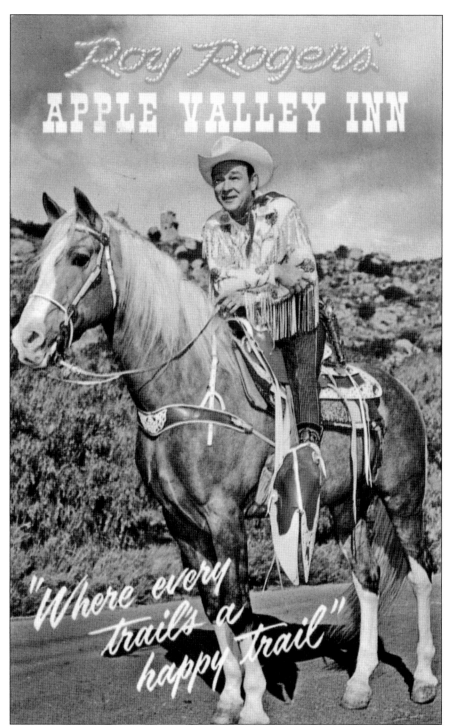

In the mid-1960s, Western stars Roy Rogers and Dale Evans retired and moved to Apple Valley near Victorville. They bought the Apple Valley Inn and built a museum in Victorville to showcase their memorabilia. Roy died in 1998, and Dale passed away in 2001. They are buried near their home, but the museum has moved to Branson, Missouri.

In *The Grapes of Wrath*, John Steinbeck described the trek of Dust Bowl migrants to Southern California: "Highway 66 is the main migrant road . . . twisting up into the mountains . . . and down into the bright and terrible desert, and across the desert to the mountains again, and into the rich California valleys."

The Prickly Pear or "Opuntia Wootoni" in Fruit T616

Many varieties of prickly pear cactus are found throughout the deserts of the American Southwest. In the Mojave Desert alone, varieties include hedgehog, plains, smooth, pancake, brown-spined, and beavertail. The thorny pear fruit is edible and nutritious, though it must be picked and peeled with care.

In his story "The Caballero's Way" (1907), O. Henry reviled prickly pears: "The uncanny shapes of the cacti lift their twisted trunks to encumber the way. To be lost in the pear is to die almost the death of the thief on the cross, pierced by nails and with grotesque shapes of all the fiends hovering about."

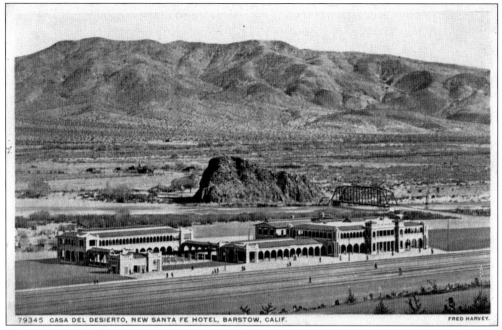

79345 CASA DEL DESIERTO, NEW SANTA FE HOTEL, BARSTOW, CALIF. FRED HARVEY.

A 1911 postcard shows the then-new Casa Del Desierto, a hotel and restaurant complex at the Santa Fe Depot in Barstow. It was considered a gem of the Harvey House chain founded by Fred Harvey. Restored in the 1990s, it is now home to the Mother Road Route 66 Museum and the Western America Rail Museum.

Barstow, founded in 1888, always has been a welcome sight for weary travelers crossing the Southern California desert. This hand-tinted 1940s postcard shows the old Beacon Hotel, a beautifully landscaped inn with a tavern and coffee shop that was popular with locals and tourists alike.

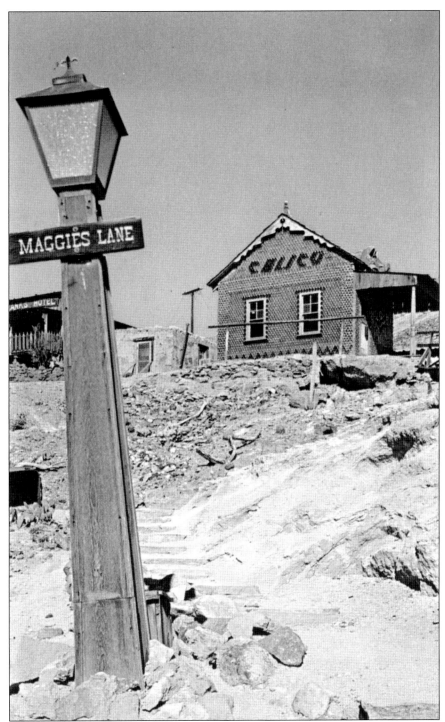

Calico, near Barstow, was a silver boomtown during the last two decades of the 1800s. It had more than 500 mines and a population of 1,200. The fact that it had 22 saloons and only two churches offers some indication of its Wild West nature. The town failed after a devastating drop in silver prices in 1907.

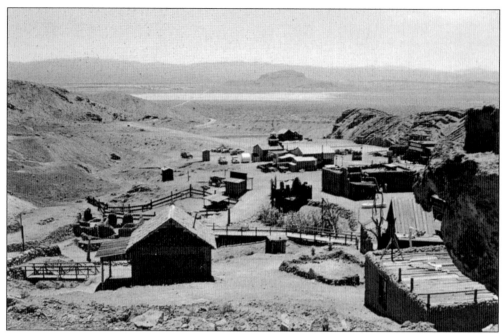

Walter Knott, founder of Knott's Berry Farm, rehabilitated Calico as a tourist attraction starting in 1950. In 1966, he donated the Calico Ghost Town to the County of San Bernardino, which today maintains it as a county regional park. It is open year-round, with Wild West reenactments and other entertainment.

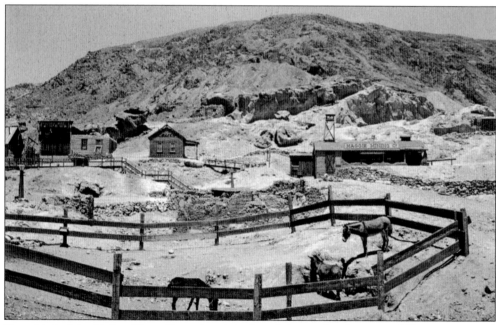

One third of the Calico Ghost Town is original, and the rest has been carefully reconstructed to restore the look of old Calico. Visitors can wine and dine in vintage cafés and saloons. They can wander through the old cemetery and explore a hard-rock silver mine. They can even hitch a ride on a pack burro.

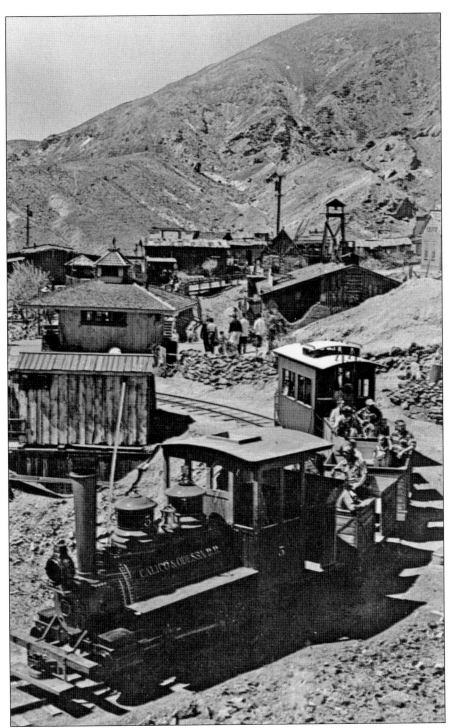

The Calico and Odessa Railroad is a working narrow-gauge railroad that originally was used, starting in 1888, to transport ore from the Waterloo and Silver King mines to the processing mill in town. Between the years of 1881 and 1896, as much as $90 million in silver was mined at Calico. Gold and borax were also mined here.

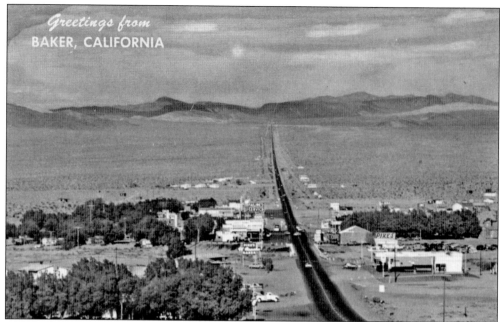

Is this the road to nowhere? No, Baker is on the road to Las Vegas, Nevada. The town, settled in 1908, is about 50 miles from the Nevada border. Baker also is a gateway to Death Valley, 25 miles north on State Highway 127. Another road leads to Zzyzx, once a health spa and now California State University's Desert Studies Center.

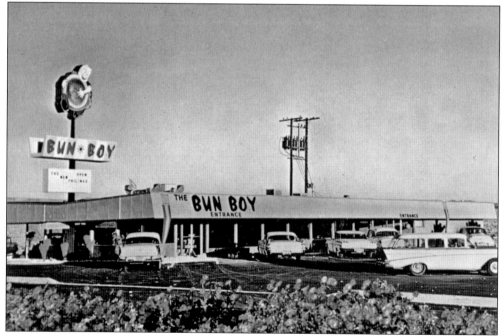

The landmark Bun Boy restaurant, which opened in Baker in 1926, became a "must stop" for generations of motorists. This 1950s postcard, issued after a remodeling, boasts that the Bun Boy is "one of the most popular eating places between San Bernardino and Las Vegas." Even celebrities stopped for food and drink.

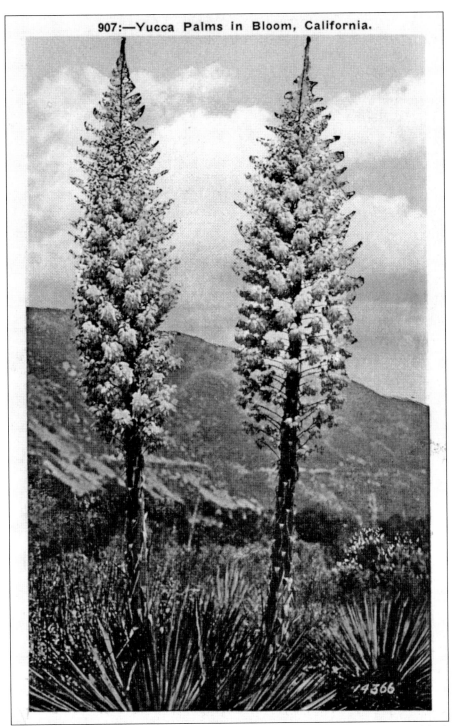

907:—Yucca Palms in Bloom, California.

Yucca trees sometimes are called yucca palms, but they are actually members of the lily family, not the palm family. Yucca trees are ubiquitous throughout the Mojave Desert. Dried yucca wood is extremely flammable, so it has been prized as tinder wood by desert dwellers and desert sojourners.

107

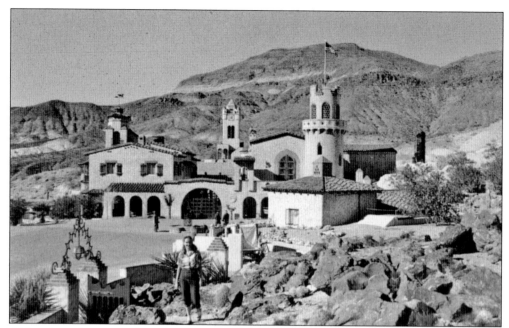

Walter Scott, known as "Death Valley Scotty," was an amiable con man who fleeced investors with big talk of desert gold. One victim, Albert Johnson, hunted Scott down. He was so charmed by Death Valley and by Scott himself that he befriended the rogue and helped him build Scotty's Castle in the 1920s.

658 SAND DUNES IN DEATH VALLEY, CALIFORNIA

Early wayfarers dubbed the area Death Valley because of its vast exposed expanses and pitiless heat. It is the site of the hottest temperature ever recorded in the United States: 134 degrees, measured on July 10, 1913. Most of Death Valley is in Inyo County, but its southern portion extends into San Bernardino County.

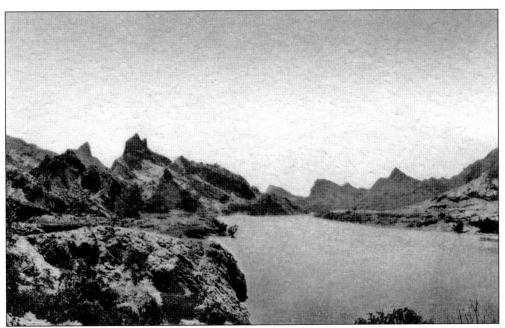

Where does Needles get its name? It comes from the distinctive pointed rock formations found here. Cartoonist Charles Schulz, creator of the *Peanuts* comic strip, spent part of his boyhood in Needles. One of the strip's characters, a dog appropriately named Spike, always yearns to return home to Needles.

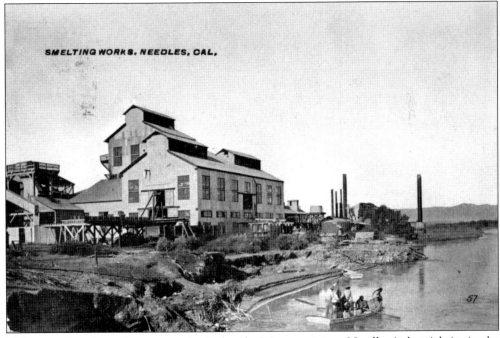

This rare view shows boaters on the Colorado River next to a Needles industrial site in the early 1900s. The penny postcard was sent home to Pasadena by a traveler to Arizona, who wrote, "All these Arizona zephyrs are sure some zephyrs. My nose and throat are simply raw from the dust. It's dear old Calif. for me."

H-1437 SANTA FE BRIDGE OVER THE COLORADO RIVER, NEAR NEEDLES, CALIFORNIA.

Needles is on the Colorado River, which divides California and Arizona. The southern tip of Nevada is also nearby, so locals use the term "Tri-State Area." They also boast of the region's recreational amenities and wide-open spaces. The city's Web site urges tourists to visit "California's East Coast."

12286 THE SANTA FE LIMITED, NEEDLES, CALIF. INDIANS SELLING BEAD WORK IN FRONT OF EL GARCES HOTEL

Needles was founded in 1883, evolving from the Santa Fe rail depot that was established there that year. Needles became an important icing station for citrus and other produce that was shipped east from Inland Empire orchards and fields. Needles was incorporated in 1913 as a California Charter City.

Legendary Wild West lawman Wyatt Earp, born in 1848, spent much time in the Inland Empire. His parents lived in Colton, and he worked odd jobs in the region between stints elsewhere. He spent his last years prospecting in the desert, living in this cabin in what is now the town of Earp, south of Needles.

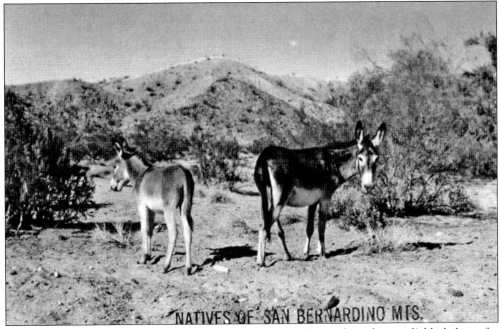

Since the California Gold Rush, commencing in 1849, burros have been reliable helpers for prospectors working claims in both the mountains and deserts. This fact helps solve the apparent puzzle presented by this old postcard, titled "Natives of San Bernardino Mts.," which shows a pair of burros in a desert setting.

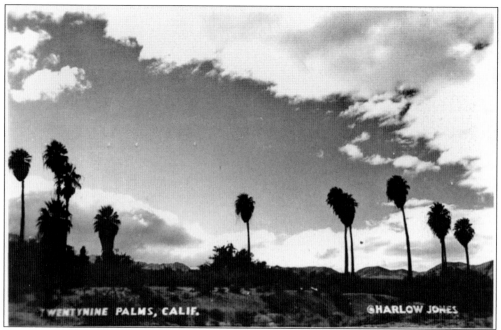

Twentynine Palms, settled by gold prospectors in the 1870s, has thousands of palm trees. The community, on the northern border of Joshua Tree National Park, gets its whimsical name from an artesian spring, known as the Oasis of Mara, which at one time was surrounded by 29 palm trees, according to local lore.

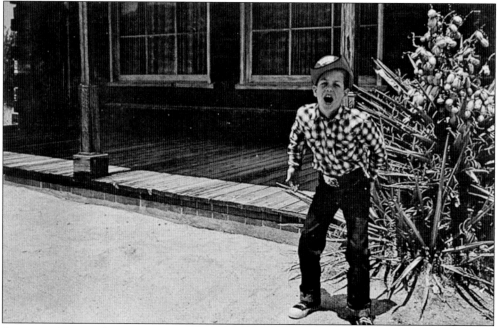

A young visitor strikes a gunslinger's pose in this 1962 postcard of Pioneertown, built in 1946 as a movie set for Westerns starring the likes of Gene Autry and Roy Rogers. Pioneertown, near Yucca Valley and Joshua Tree National Park, still draws tourists, who often stop for food, drink, and music at Pappy and Harriet's.

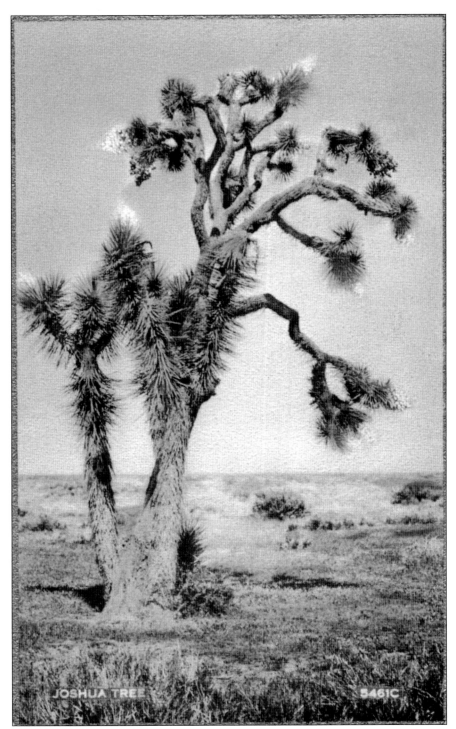

The Joshua tree, so plentiful in Joshua Tree National Park, intrigues visitors from around the world. This old card was picked up by a German tourist, who filled it out but never sent it. Perhaps he decided not to part with it after all. Joshua Tree National Park straddles San Bernardino and Riverside Counties.

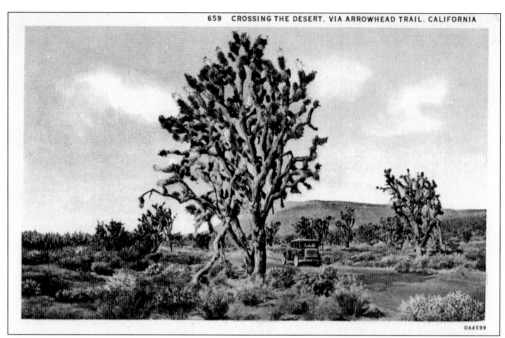

The story goes that Joshua trees were named by the Mormon settlers who founded San Bernardino. Those Bible-minded pioneers thought the trees resembled the Old Testament character of Joshua, who with God's help lifted his arms and commanded the sun to stop in its tracks, thus helping the Israelites win a key battle.

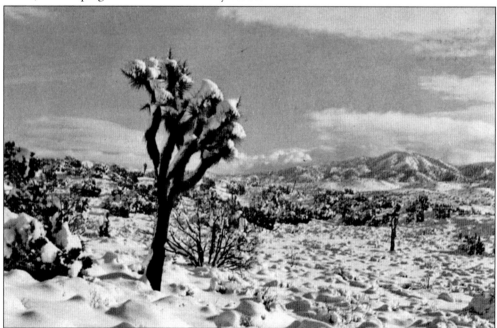

Snow is not unusual in the High Desert, with elevations ranging up to 6,000 feet in parts of Joshua Tree National Park. Two deserts meet here, the hotter Colorado Desert in the east and the higher, cooler Mojave Desert in the west, where most of the park's famous Joshua trees are found.

114

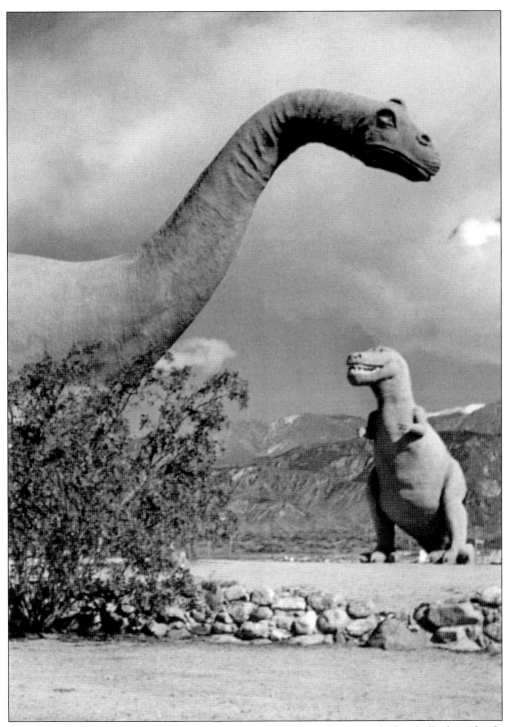

The famous Cabazon Dinosaurs near Palm Springs were built single-handedly by Claude Bell, a retired Knott's Berry Farm designer. He started in 1964, using scrap metal from the construction of Interstate 10, and worked until his death in 1988. The behemoth creatures have been featured in many movies and commercials.

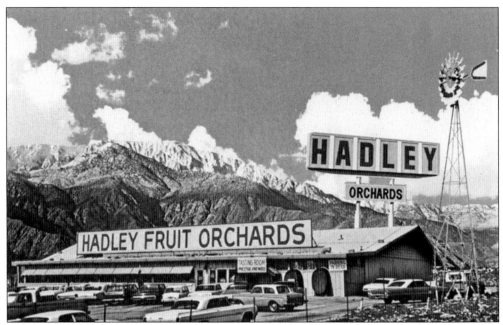

Hadley Fruit Orchards, established in 1931, is another Cabazon landmark. Founder Paul Hadley invented the fruit-and-nut combination now known as trail mix, which he sold to hikers on their way to the nearby San Jacinto Mountains. Today Hadley's offers the "world's largest selection" of nuts, dried fruit, and dates.

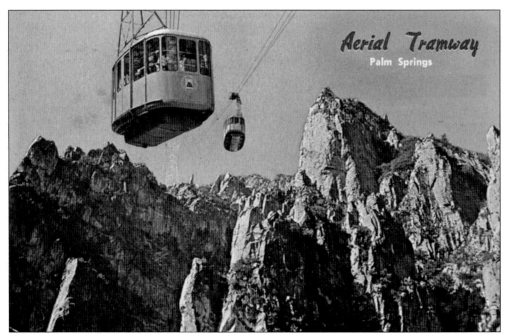

The Palm Springs Aerial Tramway, after 30 years of planning and building, opened in 1963. It carries passengers 6,000 feet up from the desert floor in Palm Springs to the lofty San Jacinto Mountains. The temperature difference can be as much as 40 degrees. In 2000, the original gondolas, seen here, were replaced by rotating tram cars, which are the world's largest.

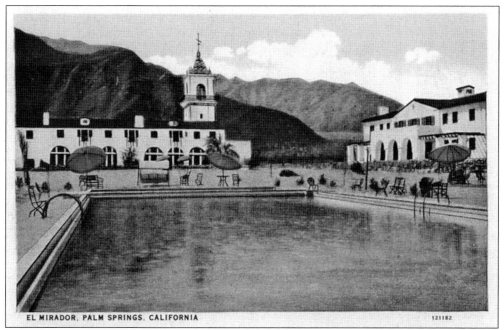

EL MIRADOR, PALM SPRINGS, CALIFORNIA

El Mirador, built in 1928, was among the flashiest, most star-studded hangouts in Palm Springs. Composer Cole Porter auditioned new tunes in the piano lounge here, it is said. During World War II, the inn was transformed into a military hospital. Today's Desert Regional Medical Center is near the location.

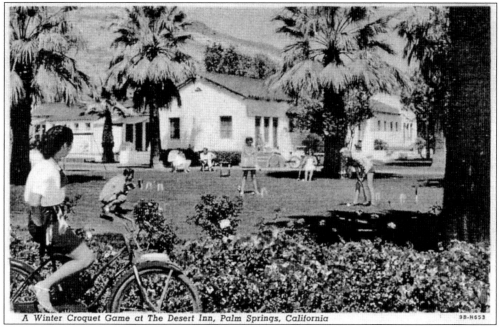

A Winter Croquet Game at The Desert Inn, Palm Springs, California

A 1940s croquet game attracts a pretty spectator on a sunny winter day at the old Desert Inn in Palm Springs. The inn was established in 1909 as a sanitarium for tuberculosis patients. Later it became an upscale resort where high-society guests such as the Hearsts and the Vanderbilts chose to stay.

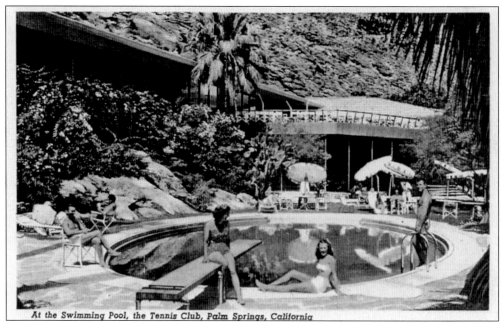

At the Swimming Pool, the Tennis Club, Palm Springs, California

The beautiful people of the 1940s bask by the pool at the Tennis Club in Palm Springs. It was said that Palm Springs had more swimming pools per capita than anywhere else in the world. It also had plenty of golf courses, tennis courts, gambling dens, and drink joints—no wonder it was a Hollywood favorite.

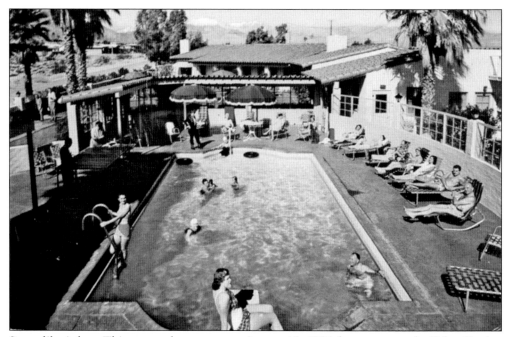

Some like it hot. This postcard was sent on August 10, 1957, by a guest at the Palm Garden Hotel in Palm Springs, who reported that "the weather has been perfect." Typically, August daytime temperatures in Palm Springs and other Coachella Valley resorts rise to between 110 and 120 degrees.

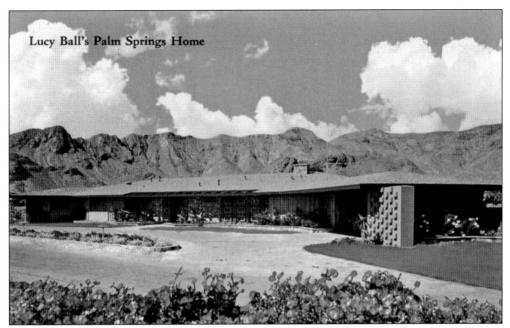

Lucy Ball's Palm Springs Home

The long list of celebrities who had homes in Palm Springs includes Elvis Presley, Frank Sinatra, Liberace, Bob Hope, Red Skelton, Gene Autry, Dinah Shore, Steve McQueen, and Sonny Bono. Pictured here is the home of comedy legend Lucille Ball, with commanding views of the Thunderbird Country Club.

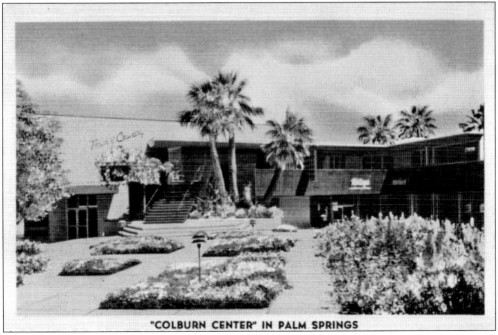

"COLBURN CENTER" IN PALM SPRINGS

The Colburn Center, built in 1948, became better known as the Town and Country Center. Located on Palm Canyon Drive, in the heart of downtown Palm Springs, it boasted upscale shops and offices, as well as the Town and Country Restaurant. Today its future is the subject of debate between redevelopers and preservationists.

On the Road to Palm Canyon near Palm Springs, California

Portal Rock, sometimes called Cleft Rock or Split Rock, is the gateway to Palm Canyon, a popular spot for hikers and picnickers on Native American–owned land near Palm Springs. Day-use passes are required. Visitors can buy Native American books, art, and food at the Trading Post shop near the canyon entrance.

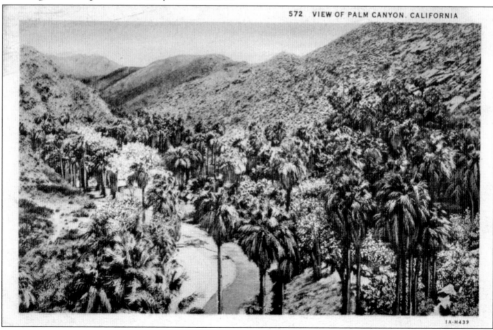

572 VIEW OF PALM CANYON. CALIFORNIA

A 15-mile trail through Palm Canyon beckons hikers today, just as it did in the 1930s when this photograph was made. The land is owned by the Agua Caliente clan of the Cahuilla tribe. Thousands of California fan palms line a stream that winds through a maze of picturesque gorges and glens.

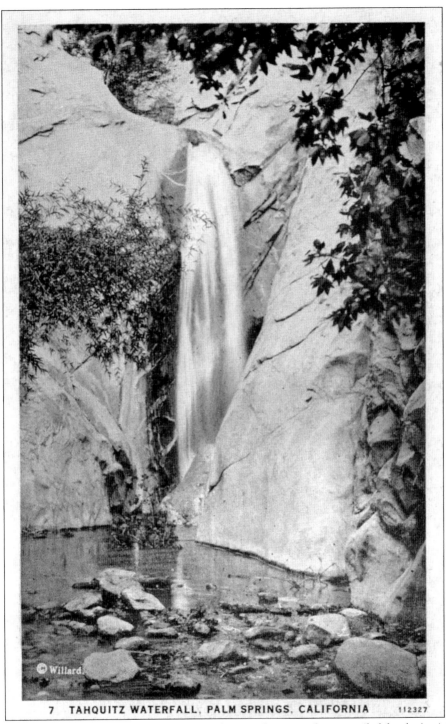

7 TAHQUITZ WATERFALL, PALM SPRINGS, CALIFORNIA 112327

The 60-foot-tall Tahquitz Waterfall is in Tahquitz Canyon, also on tribal land. A visitors' center is near the entrance. The caption on the back of this 1930s card notes that the falls are just a mile from downtown Palm Springs: "The trip to this beautiful spot makes one of the most popular morning or evening walks."

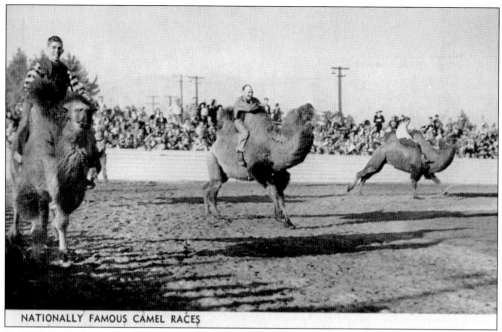

NATIONALLY FAMOUS CAMEL RACES

In 1921, Indio hosted its first National Date Festival to celebrate the winter date harvest. From the beginning, the festival had an "Arabian Nights" theme, and camel races were part of the fun. The festival is still held each February. Today it is called the Riverside County Fair and National Date Festival.

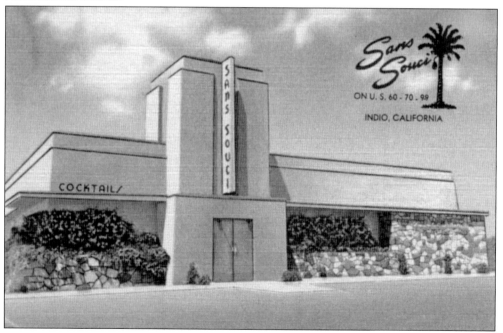

Indio, 26 miles east of Palm Springs, calls itself the "City of Festivals" because, in addition to the National Date Festival, it hosts the International Tamale Festival each December and the Coachella Valley Music and Arts Festival in the spring. Seen here is the Sans Souci, a popular hangout during the 1960s.

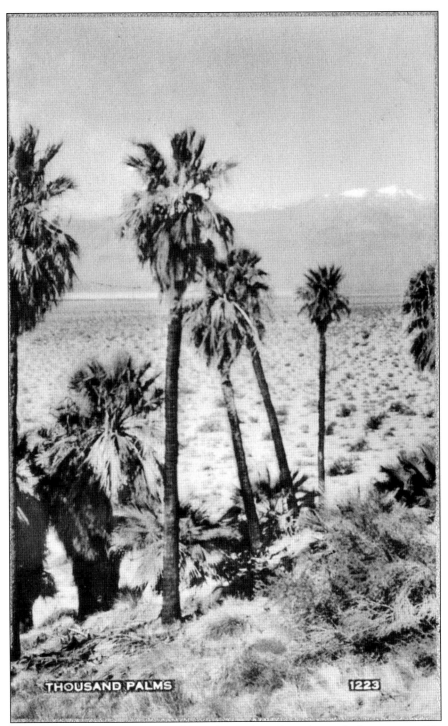

THOUSAND PALMS 1223

The Coachella Valley is still dominated by Palm Springs, but a host of other communities have evolved to form an impressive constellation of desert resorts, including Indio, Palm Desert, Rancho Mirage, Cathedral City, Indian Wells, Desert Hot Springs, and Thousand Palms. Each one offers distinctive amenities.

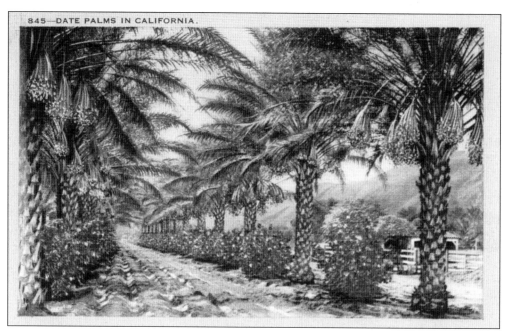

845—DATE PALMS IN CALIFORNIA.

Virtually all dates consumed in the United States are grown in and around Indio. Annual production is about 45 million pounds, with an industry value of about $35 million. Visitors can stop at many roadside establishments to enjoy date shakes and buy boxes of Deglet Noors, Medjools, or a dozen other varieties.

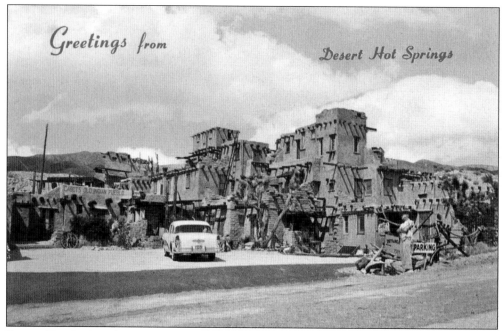

Greetings from Desert Hot Springs

Desert Hot Springs homesteader Cabot Yerxa stands in front of his handmade Old Indian Pueblo in this 1950s postcard. Starting in 1941, he spent more than 20 years constructing a 35-room adobe house using castoff materials. A tourist attraction even before his death in 1965, Cabot's Old Indian Pueblo still draws crowds.

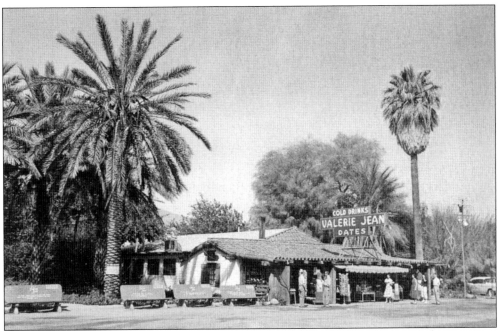

The landmark Valerie Jean Date Shop in Thermal was built from timber and railroad ties that were abandoned when the Salton Sea was being formed. Thermal is on the road between Indio and the Salton Sea, and the date shop was a popular stop. Many tourists posed for pictures in front of the 1912 King Solomon palm (left).

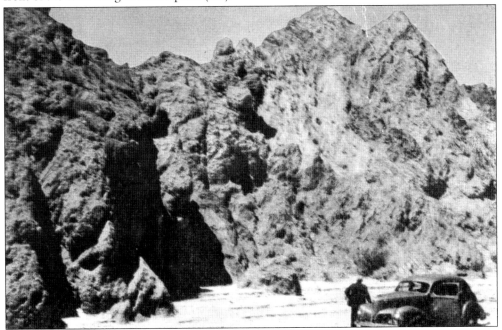

Painted Canyon near Mecca, about 40 miles southeast of Palm Springs, offers tourists a look at ancient upheavals of mineral-rich rock in shades of red, blue, and green. Mecca and Thermal are on the San Andreas Fault, which terminates at the Salton Sea. This postcard dates from the 1940s.

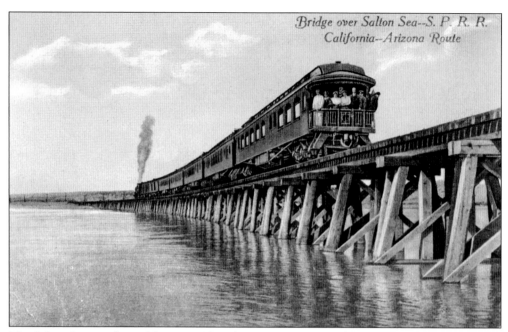

The Salton Sea was formed by an accidental two-year rupture of a man-made Colorado River pipeline in 1905–1907 that caused the town of Salton and the main line of the Southern Pacific Railroad to be inundated. Construction of elevated tracks restored train service and also allowed excursion viewing of the forming "sea."

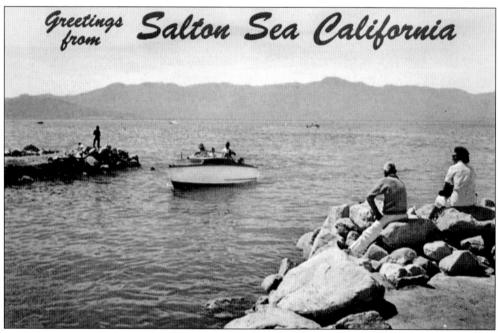

Greetings from **Salton Sea California**

The Salton Sea, which straddles southeast Riverside County and northwest Imperial County to the south, is the largest body of surface water in California—greater even than Lake Tahoe. With no outlet and an abundance of lake-bed minerals, the man-made "sea" has become saltier even than the ocean.

126

In its freshwater heyday in the 1950s and early 1960s, the Salton Sea was a thriving resort and celebrity hangout. It drew more tourists each year than Yosemite. This postcard was sent in December 1962 by a visitor who wrote, "Here we are, catching them big ones. Having a fine time in this pretty warm sunshine."

Across America, People are Discovering Something Wonderful. *Their Heritage.*

Arcadia Publishing is the leading local history publisher in the United States. With more than 4,000 titles in print and hundreds of new titles released every year, Arcadia has extensive specialized experience chronicling the history of communities and celebrating America's hidden stories, bringing to life the people, places, and events from the past. To discover the history of other communities across the nation, please visit:

www.arcadiapublishing.com

Customized search tools allow you to find regional history books about the town where you grew up, the cities where your friends and family live, the town where your parents met, or even that retirement spot you've been dreaming about.